CREDO

Mark Wallinger

TATE LIVERPOOL

Published to accompany the exhibition

Mark Wallinger

CREDO

20 October – 23 December 2000

Organised by Tate Liverpool

Supported by the Henry Moore Foundation

This exhbition includes *Cave* 2000,

a FACT commission in collaboration

with Tate Liverpool made possible with financial support from

the Arts Council of England's Touring Programme and North West Arts Board.

FOUNDATION FOR ART & CREATIVE TECHNOLOGY

Published and distributed by Tate Gallery Publishing Limited

Millbank

London sw1p 4rg

isbn 1 85437 325 0

Designed by Alan Ward at Axis Design, Manchester

Printed by Finchmark, Stockport

Front cover: *Ecce Homo* 1999 in Trafalgar Square,

front cover photograph © John Riddy

Back cover: *Cave*, 2000 (detail)

Inside cover: *Monkey*, 1992 (detail)

Pages 1 and 128: *Passport Control*, 1988

Contents

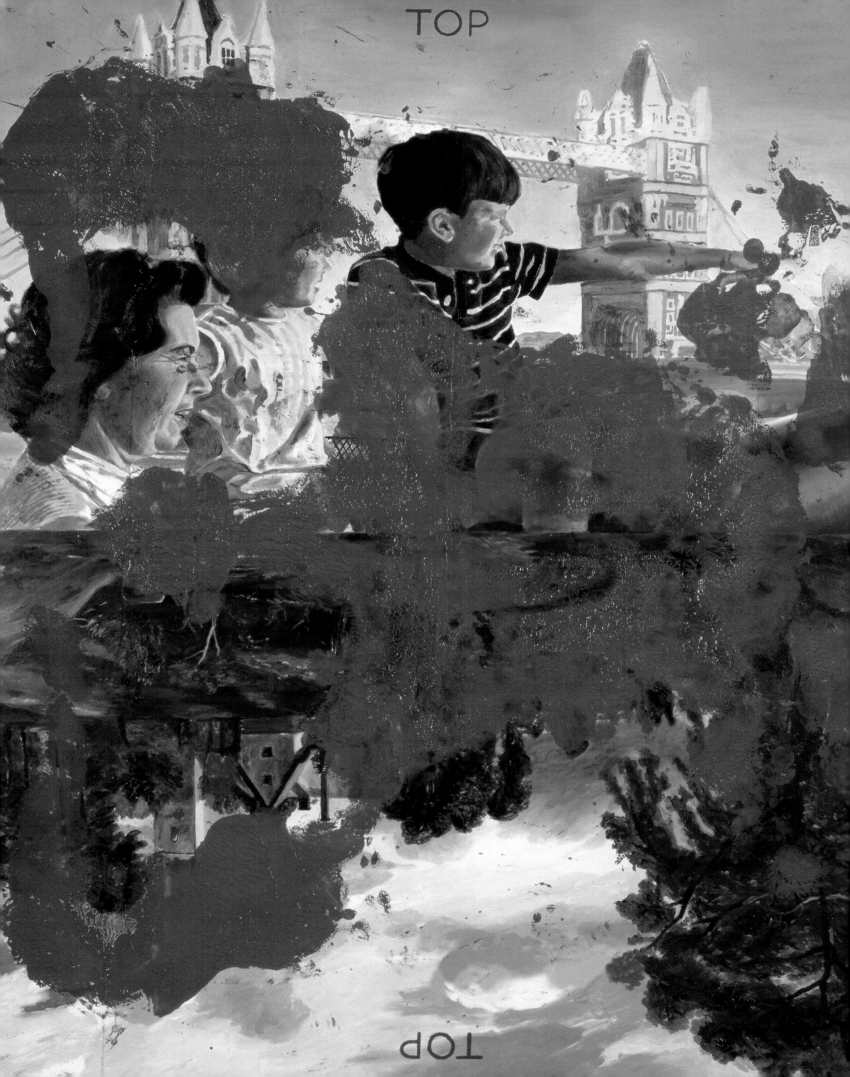

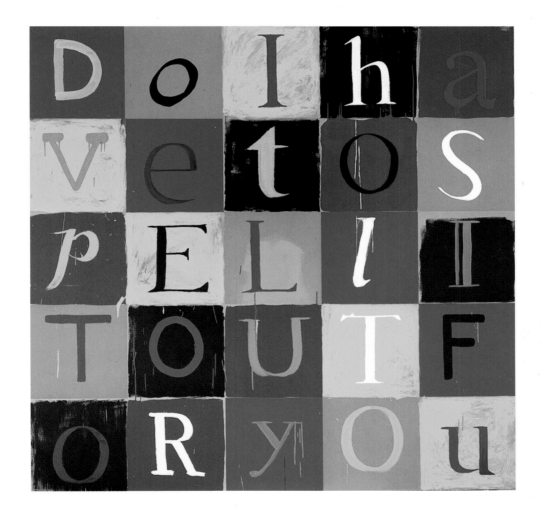

Q1, 1994

LEFT: **The Bottom Line**, 1986

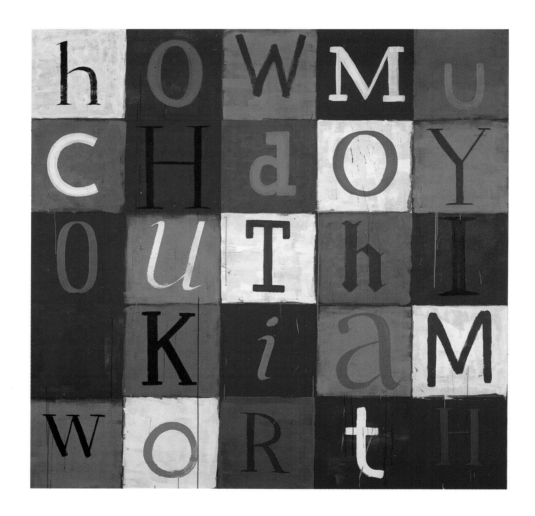

Q2, 1994

Preface

This book, published on the occasion of the exhibition *Credo* at Tate Liverpool, presents an opportunity to examine works of art from all points of the artist's career. Along with the largest selection of images of Wallinger's work published to date, it includes a newly commissioned essay that surveys his career and examines his most recent pieces. We are extremely grateful to Ian Hunt, publisher of the poetry imprint Alfred David Editions, and David Burrows for their insightful essays offering engaging new perspectives on the art. Our sincere thanks go to Anthony Reynolds and the staff at Anthony Reynolds Gallery, Jane Bhoyroo and Tristram Pye. We would like to thank Eddie Berg and Jo McGonigal from FACT, Martin and Simon Wallace from Nova Inc. Film and TV Ltd. and Tom Cullen for their contribution in realising *Cave*, a major new video installation commissioned for the exhibition. We are indebted to the Trustees of the Henry Moore Foundation for its support of both the show and this publication. We are also extremely grateful to all the lenders who have generously supported the exhibition by allowing us to borrow key works.

Our final and greatest thanks go to Mark Wallinger himself for all his enthusiasm and energy in working closely with us to realise the exhibition and this book. His patience, generosity and good humour hugely informed both projects.

Lewis Biggs
Director Tate Liverpool

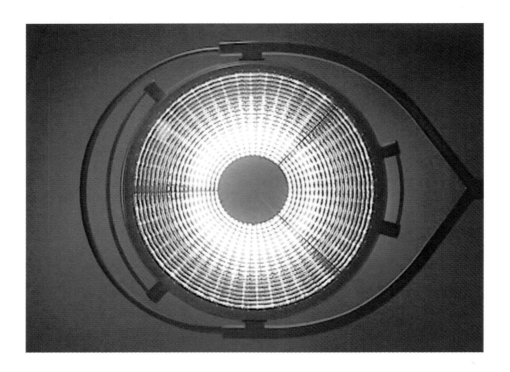

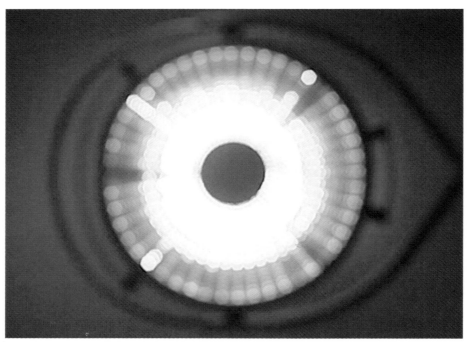

On an Operating Table, 1998

Introduction

Mark Wallinger's work takes many forms, and displays a restless energy that is both intelligently provocative and humorous. His work has been consistently elusive, determinedly without stylistic 'signature', so that it is perhaps surprising – and heartening – that it should have gained such widespread recognition over the last fifteen years, the subject of solo exhibitions in New York, Basel, Frankfurt, Rome, Milan, Vienna and Brussels, while in 2001 he will represent Britain at the Venice Biennale. This book is published to coincide with the largest exhibition of his work to date, *Credo*, at Tate Liverpool, October-December 2000.

Wallinger attended Chelsea School of Art and was a graduate of Goldsmiths College, London, which had a reputation for teaching the use of innovatory media. However, it had been his paintings that first gained him critical attention in the mid 1980s, and *Credo* shows both early and recent paintings, along with the several other media he has mastered, in order to draw attention to the continuous threads of content that bind the work together in no matter what medium.

A strong element of political satire and moral commentary underlines his practice – a content that places him at some distance from most of the younger British artists to emerge in the 1990s, even if they share his love of humour. Employing irony, satire and formal clarity, Wallinger discovers and explores the complex themes of identity, class, race, humour and spirituality. His primary concern has been to establish a valid critical approach towards the 'politics of representation and the representation of politics'.

Wallinger sees his environment as a culture of contradiction, tradition and quiet revolution. Much of his earlier work is concerned with the nature of 'Englishness'; particularly its construction in a multi-cultural society. This extended to an investigation of the sports in which he is himself thoroughly immersed – notably football and horse-racing – as 'locations' which simultaneously transgress and entrench class differences. His choice of subjects is always fuelled by this personal and passionate interest, so that the critical edge of his work is tinged with the sensibility of a 'fan'. He never preaches, merely shares his concerns with us. As he said in a recent interview (with Colin Gleadell): 'As soon as art becomes didactic, I'm not interested. I'm more interested in art that is genuinely ambiguous in which the preconceptions of the viewer are imperilled.' His recent work deals with varied subjects such as religious faith and atheism, life-cycles, and the relation of the individual to the State, always characterised (as is his writing) by violent swings from the abstract and ethereal to the concrete and the gritty.

There is a perennial youthfulness about Wallinger's work, a naïve necessity ("Mark Wallinger Is Innocent") to ask the big questions that we try to put aside after adolescence: Where do I belong? Who do I belong with? What does it mean to believe in something? How will it change the way I experience the world if I do believe it? (Will I still have any friends if I do?) What happens to us

when we die? Or when we press the button to kill someone? In all, his work is fugitive and contradictory, funny and grave: that is to say, it is exceptionally human. Always there is the recognition that art, like so many other parts of life, is in itself a belief system, requiring the goodwill and participation of the viewer.

Lewis Biggs
Director Tate Liverpool

The eye is
not satisfied
with seeing,
nor the ear
filled with
hearing

Ecclesiastes 1:8

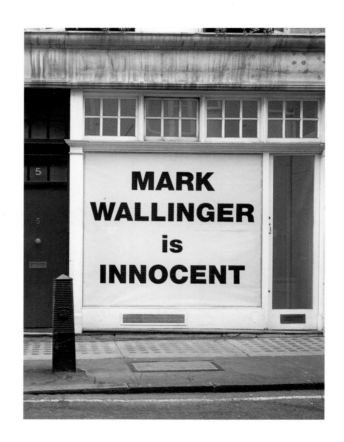

Mark Wallinger is Innocent, 1997

Protesting Innocence

'MARK WALLINGER is INNOCENT'. We do not know what he is innocent of, and the form of his protest — posters and postcards in which the slogan is proclaimed — updated a graffiti campaign to free from jail a London criminal who promptly re-offended, after his release had been secured. His innocence is still believed by certain south London walls.[1] But the statement is nevertheless true with regard to Mark Wallinger, or at any rate, I find myself believing it.

'There's no art/ To find the mind's construction in the face.' But when someone's character is cast into doubt, we still try to look them in the eye. Works in which the artist's face appears convince me of some essential quality of innocence. In a billboard-sized colour photograph made in 1994, *Mark Wallinger / 31 Hayes Court / Camberwell New Road / Camberwell / London / England / Great Britain / Europe / The World / The Solar System / The Galaxy / The Universe*, a long-haired Wallinger can be seen in the middle distance, holding up a flag large enough to require a brother on the other of the two poles. Although standing still among crowds that are moving, Wallinger perhaps reveals a slight sense of anxiety at carrying through this hare-brained idea for the sake of art, raising an enormous Union Jack with his own name across its middle. But he produces from this situation a comical look, that while it definitely shares some kind of joke with the viewer, does not thereby make fun of anyone else, least of all any of the crowd on their way into the football ground, some of whom also make use of the presence of the camera.

A similar comical expression can be found in a documentary photo taken in Brixton, on a roof, during the raising of *Oxymoron* in 1997. The design was again that of the Union Jack, but the colours were replaced with their optical complimentaries, which are those of the Irish tricolour: a gesture which you can get away with in south London. The photograph inevitably parodies those iconic records of American flags raised by troops in battle. But no gratuitous insult was being offered to either side of the sectarian divide by this work; or to a south London audience made aware of its good fortune at not having to be greatly exercised by such symbols, still individually recognisable in their combination as they were. What was the appropriate face to make when erecting a work in which it is recognised that identities have been produced that are far from easily tractable, which have reshaped the geography of cities, and have to be lived with as well as struggled against? Wallinger made an amused, non-victorious expression; it could perhaps be glossed as Hope defeating Dogma, with Laughter in attendance. Perhaps it was simply the only usable photo. But it shows Wallinger's wish to share the absurdity of the situation with the camera, to which he commits himself with no fraud. Beyond that, it demonstrates perhaps his ability to take part in a fantasy — of a time when patterns of identification in such symbols will cease to hold their present meanings — without either fully believing it, or believing it can be allowed to be thought impossible.

The balancing of respect for and challenge to the audience's intelligence and feelings was pursued in *Ecce Homo* 1999, a white marble-resin sculpture of Christ erected in Trafalgar Square from 21 July 1999 to 11 February 2000. The sculpture made palpable the moment, in the Gospel of St. John, when the crowd was stirred up to choose which of the candidates for crucifixion was to be spared (John, 18:28 to 19:5). Wallinger stated that it represented a reminder that 'Democracy is about the right of minorities to have free expression, not the majority to browbeat and marginalise.' By focusing on the moment when a crowd was faced with a bad choice in the story, and shouted support for the bandit Barrabas, the sculpture permitted reflection on the harm involved in any moment that involves a false choice between being 'with us' or 'against us'. At the local level, a connection was being affirmed, in the traditional focus for protest and public marches, to both the Christian nonconformist contribution to radical social movements, and simultaneously to the suppressed Catholic aesthetic of religious statuary in public places. The surprise of many British viewers that they had never before looked at a serious Christian sculpture arose not just from the choice of an unfamiliar moment in the story, but from the lingering effects of a Protestant image ban which has delivered larger quantities of bronze generals to public places than it has sculptures that exalt the people or the spirit.

Ecce Homo represented the moment when the protesting innocence that had always been present within Wallinger's project went overground, as it were. It was finally recognised as an essential aspect of the wit and intelligence he had shown all along, which ally his approach broadly with traditions of reasoning and generous scepticism rather than with stoic self-reliance or child-like revolt. This evident intelligence, incidentally, had always been antipathetic to the idea that the interchange between the real, the imagined and the longed for could be other than complex matters, rather than a generalised assumption that somehow life was just getting more and more fictional. This debilitating perception is visible in many recent cultural productions, from forms of warfare in which technological inequality transforms, though it does not finally erode, the reach of terms such as just or unjust; to television's overdosing on spectacularised private life, within which structural political and social conflicts find mal-expression and must remain largely unexamined. Real changes in communications, society and politics are at stake here. It should be no surprise that time often passes before substantial artistic reflection or response to such changes arises. Very often in art, more supple political work gets done in acts of retrospection than in conforming to the positioned responses of the time.

Wallinger's seven-part work *Capital* 1990, for which he painted full-length portraits of friends dressed as homeless persons, framed by the bronze doors and porticoes of City financial institutions, remains pertinent here for its formal conviction and intent. Wallinger's work had always taken a critical stance, but it was as though some of the internal

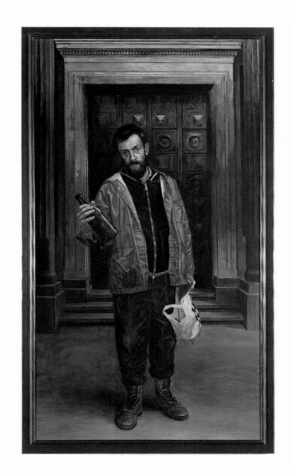

Capital, 1990 (detail)

transformations wrought in this period and the poverty of its satire were only making themselves available for comprehension as the 1980s reached their end.[2] The Brechtian dislocation of this work, its faked and costumed vagrancy, courted a degree of bewilderment; it reopened the possibility in viewers' minds that it could easily be their own face that they saw looking out. Beyond that, *Capital* could be said to frame a genuinely open question: 'Of what are we being dispossessed?' Doubts about the reach of the first person plural – which suffered historic damage in the decade or so preceding the work – are part of this question. The refusal of one level of mimetic demand, painting authentic homeless people, permits representation of deeper doubts; secrecy wears a human dress.

Such moments of vulnerability in Wallinger's work may imply a Blakean understanding of the protest of innocence within experience. Some form of commitment on that level must be allowed, because despite Wallinger's continued and critical faith in ways of art-making that reveal the constructedness of meaning at the spatial, perceptual and cultural levels, his are not God-like deconstructions from a position outside the problematics they tackle. Already in 1986 the face of William Blake (from the death mask) had appeared on a Toby Jug, in a painting called *In the Hands of the Dilettanti* 1986, adapted from a detail of a painting by Joshua Reynolds, *Members of the Society of Dilettanti* 1779. It is hard not to discern an implied sympathy for the unseen poet. Wallinger's work in all periods is iconologically and referentially rich – his content has content, not simply an animus against the late modernist painting he felt browbeaten by in his first years as a student. He has said that 'If by belief or temperament one is more concerned with the world as it is, rather than what art could be, there is nothing that is not already saturated with meaning.' But the allegorical strategies of early paintings such as these were being questioned. The dangers of relying too heavily on such evocative prompts, and indeed on visual habits all too satisfied with a process of reading out meanings that the artist has put in, but leaving the meanings themselves unchanged, were recognised. In an interview with Theodora Vischer in 1999, Wallinger was careful to quote Oscar Wilde:

> All art is at once surface and symbol.
> Those who go beneath the surface do so at their own peril.
> Those who read the symbol do so at their own peril.
> It is the spectator, and not life, that art really mirrors.

The need to emphasise this point is perhaps a result of having learnt the hard way that referential range and generosity can backfire; that content will often be regarded as transparent. But even in early works, dislocations were being explored that were capable of doing far more than allowing the viewer the comfort of their own opinions. *Lost Horizon* 1986 makes reading and naming part of its subject, though within a tradition of painting familiar

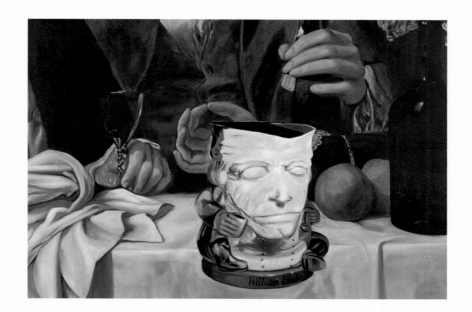

In the Hands of the Dilettanti, 1986

from many a stately home. By inscribing 'Lord Wilson of Rielvaux' above the country seat, along with the Christian names John, Ringo, Paul and George, a toy guardsman and a china Shire horse, Wallinger was recording the current title of the former Prime Minister, some years after the decade with which all five names are strongly associated. A contrast was clearly intended between the Labour peer and the pop group who – if we start thinking about titles – once returned their Orders of the British Empire in protest at the Labour government's support for the war in Vietnam.

What the painting depicts is a topography that, although studded by interpretable signs, was becoming distinctly challenged in its historical sense. Names float in ambiguous spatial relationship to images (their positions are in fact taken from a 1964 photo in which Wilson posed with the group at the Royal Variety Club awards). In *Lost Horizon*, this sense that signification itself is becoming weakened is not an attempt to illustrate or join an art-school approved tradition of thinking; in fact to use such British content at all felt at the time like a rebuke to assumptions about the supposed international reach of art. It was rather to represent the ease with which the elision and remaking of cultural history in Britain could be effected – or could be imagined to be effected – over and against the memories and traditions that sustain more complex and ironised ideas of belonging appropriate to the times.

It is impossible to look at *Lost Horizon* now without thinking of subsequent adventures in 'rebranding' Britain that greeted the end of Conservative rule. 'One message these controversies transmitted was that the meaning of nationality and the idea of national distinctiveness are now imagined to be infinitely manipulable ... Something as stubbornly elusive as a postcolonial British identity can supposedly be designed on the drawing board and then projected into the world with such subtle force that it springs to life irrespective of any manifest historical or political obstacles to its spontaneous production,' writes Paul Gilroy in *Between Camps*.[3]

In *Lost Horizon* the china horse and the toy guardsman are finally the most solid things in the painting; indeed they perhaps qualify as among those political obstacles to which Gilroy refers. They are part of a material history of objects that stand in for and are mutely expressive of the lives of absent subjects; who may indeed suspect they have been sold lies, somewhere along the line, but have made their peace with that. The horse in particular attests to the continued resilience in Britain of cross-class fantasies about country life. The racecourse was subsequently to provide Wallinger with a rich territory for exploration of beauty, breeding, representation (the racehorse *A Real Work of Art*, winner at Rheim, Germany in 1995 and now with two foals to her credit) and finally, in *Royal Ascot* 1994, constitutional inertia.

Royal Ascot consists of four video monitors arranged in a row on top of four wheeled flightcases. The footage shows the progress of the Royal carriage down the course, four times, and the BBC commentary is quadrupled into babble. It is only slowly that you come to realise

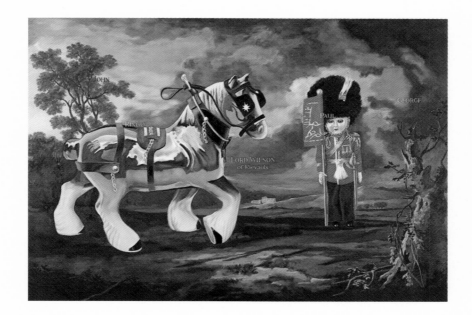

Lost Horizon, 1986

that the frock and hat worn by the Queen is different on each journey, and that the recordings represent four different occasions — the Tuesday, the Wednesday, the Thursday and the Friday of Royal Ascot — all choreographed with the utmost precision. It almost seems that the moment at which the Duke of Edinburgh tips his hat is planned to the second. The end point in each case is the moment when the National Anthem strikes up. *Royal Ascot* was made in a period when discussion of the monarchy was prominent in Britain and the question of whether it had had its day was being asked. Artists who engage with political debate must expect their works to date as circumstances change. The way Royal Ascot has aged forces viewers into some form of political self-accounting. To style oneself a republican in 2000 has a curiously historic ring, and it has certainly again become bad form to mention it in that some of the more serious constitutional questions have been tackled. The question has now been deferred although it has, or had, the particular merit of engaging a wider range of people in debate about the society they live in and the appropriateness of its political symbolism.

Although *Royal Ascot* appears to be one of Wallinger's more public works, a poem of the same title exists.

> imagine a parade with perfect
> horses drawing carriages bearing
> dignified people in beautiful clothes
> kings and queens and princes and princesses
> acclaimed by an adoring public
> the guardsman playing the national anthem

Three verses follow;[4] some lines are repeated in each, some lines sound familiar but use small changes of vocabulary; but there is no escape from the imagining of the endless pageant. The four verses achieve a satisfying verbal parallel to the video work and the existence of a poetic version of *Royal Ascot* does change one's sense that the video work is some kind of public statement. It makes it possible to see *Royal Ascot* as a private protest and analysis of a situation which appears baffling or intolerable rather than a piece of speech-making, which is relevant if one considers that the window of opportunity for genuine public debate on the matter has somehow closed again, and that the remaining misgivings must be relegated to a private or only semi-public sphere, such as art.

One of the surprising things, looking at the way Wallinger's work has developed, is that though possessing a particular feel for imagery that is familiar and demotic, and starting out from a vulnerable and identifiable political commitment, far from Marcel Duchamp's chess-playing sniffiness, this is one of the few bodies of work of the period that sustains extended consideration along Duchampian lines. This is especially so in the emphasis on the mind, not

the object, as the place where meaning is created and beliefs are assembled. Doublings and mirrorings announce this interest and can be found in the early paintings such as *Satire Sat Here* 1986, with its palindromic 'GAG' for a mouth, and *The Bottom Line* 1986. This construction hinged a painted version of a family photograph showing Wallinger with his mother and brother at the Tower of London to a repainted Constable, recognisable as such though upside down. Red paint was squeezed between the two repainted images to make a large Rorschach blot overlaying both, which makes the whole work hard for the viewer to organise visually. Past both the personal and cultural are projections, as into a Rorschach personality test, but an uneasiness is introduced into this work by the use of a family photograph; the two sides of the equation, the generalised and the specific past, don't add up.

In works such as *Object Lesson* 1990/1995, a desk doubled on top of its likeness so as to render each the image of the other; and with a mirror in between the two so that real and reflected seemingly coincide. As Wallinger's thoughts turned more towards the nature of belief and the unfinished business art has with religion – revealed and unrevealed – he arrived at works such as *Miracle* 1997 and *Upside Down and Back to Front, the Spirit meets the Optic in Illusion* 1997. The latter, a bottle of water and spirit dispenser, labelled upside down as with bottles arranged behind pub bars but also printed and signed in reverse, is only complete when placed on a mirror. In that the name and the date of birth of the artist is spatially identified in the same schoolboy style as we saw earlier ('Chigwell, Essex, England, Great Britain, Europe, The World, The Solar System, The Galaxy, The Universe') the temporal and spatial limits of the artist's 'spirit' are made clear, if somewhat vaingloriously, as conditions of this idea of non-corporeality within the corporeal that we can neither delete nor fully understand, even in states of intoxication.

Optical techniques and illusions – necessary to prove the lesson we are seemingly reluctant to learn, that seeing is only one part of our sensory and intellectual means of apprehension – have extended to the use of red and green spectacles which allow specially printed texts offset in magenta and cyan to appear in 3-D, as though floating off the wall. *Credo I* 2000 is from Ecclesiastes: 'The eye is not satisfied with seeing, nor the ear filled with hearing.' The quotation was selected by the artist for what he has called its 'powerful evocation of desire'. It is worth working backwards from this statement, and thinking through the artist's intention to make a work about desire, and then reckoning with the strange form it has taken: words rather than images. Eroticism is an area of learnt and discovered human behaviour that has been transformed by the compulsion to see and to show, and by the recent industrial revolutions in technologies of reproduction of images. No artist can be unaffected by or unaware of these changes. It is only now becoming clearer – consider the erotic power of the scripts and the gestures of actors in films from eras of cinema in which censorship rules were

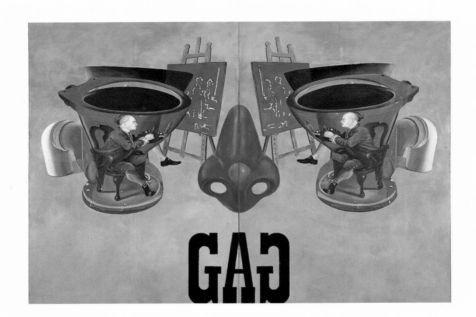

Satire Sat Here, 1986

more secure – what might be being censored by the demand to see. It is a demand that many of Wallinger's artist contemporaries have colluded with or attempted to exceed. *Credo I*, an article of faith if we are to believe the title, goes in the opposite direction, evoking the endlessness of desire via words seen through rose- and emerald-tinted spectacles and a format resembling the posters displayed outside churches.

What is so engaging about Wallinger's journey to this area of speculative endeavour, emphasising the brain's interaction with the retinal, is that it has been arrived at by thinking through the particular limits of his activity at each stage. The strong demands of content do not diminish, as we have seen in *Credo I*, a work that attempts to represent some of the paradoxes and hopefulness of desire, which is the true subject of the work. Nor is there any trace of that inverted provincialism which has often been over-ready to write off the resources of English life and culture, along with its problems. Blake's poetry, I would suggest, is among these resources. In that some of the Duchampian parallels have already been made clear[5], I would like to look in more detail at the way some of Wallinger's more recent works might be seen in relation to Blake's ideas, as a means of approaching his evident divergence in spirit from the strategies of many of his British contemporaries. In particular, I want to use Blake's best known poems, the *Songs of Innocence and of Experience*, as a way of introducing Wallinger's video works, which have had recourse to songs and share with lyric poetry a simplicity of means and a quality of temporal strangeness.

The time of the *Songs of Innocence* is immediate, present to sense, joyful and animated by energy. It is the time of the new-born, of children who would play longer, as long as the light lasts, rather than sleep, who cannot imagine that a day must end, and of adults who see no need to inflict their own perception of time onto the child's. 'Youth-time' is contrasted with age, and aged persons remember their own youth, but they do so without regret. There are possibilities for sorrow in this world, and a knowledge that winter follows summer, that sports do sometimes end; but a full understanding that death represents a serious ending is not yet apparent. The child's faith in the Lamb, the Redeemer, is genuine but it has not been put to the test. The time of the *Songs of Experience*, in contrast, is mortal, finite. Within the finite status of time – the sublunary world which remains the focus of concern, whatever the religious framework of future time and Christian belief involved actually is – repetition becomes apparent, repetition which renders moments equivalent and captures energy in unproductive cycles. Desire becomes shackled, sweetness rots; the tree of deceitfulness grows within the human brain. One example must suffice:

> Ah, sunflower, weary of time,
> Who countest the steps of the sun,
> Seeking after that sweet golden clime

Where the traveller's journey is done;
Where the youth pined away with desire
And the pale virgin shrouded in snow
Arise from their graves and aspire
Where my sunflower wishes to go.

The circularity loops from the first line to the last, but the simplicity of movement conceals great temporal variety. Technically this is a single address or sentence, a single breath of a poem that does not find completion in an action, but only in an aspiration. The subject, the sunflower, subsides from view in favour of the traveller, the youth and the pale virgin before returning, but in the last line it becomes 'my sunflower' and the speaker's presence is adumbrated just as the poem is leaving us. Such complexity within simplicity bears long thinking on, and yet its effects can be grasped by a child; which is not a bad model for contemporary works of art.

In Wallinger's works curious temporalities, reversals, and suspensions can be found; notably in *Cave* 2000 and the video trilogy comprising *Angel* 1997, *Hymn* 1997 and *Prometheus* 1999. These temporalities are a protest against the identification of video in particular with the function of documenting, which is not allowed to dominate the truths with which art is concerned. But it is a protest from within, as it were, employing the verisimilitude of the single take, which records a carefully rehearsed performance.

In *Angel* — the title does not identify the character, but names the London tube station where the work was made — an entire performance was planned in reverse so that it could be screened backwards in the gallery. Everything that happens has already happened, as in some versions of Christian faith. Wallinger devised a notation for speaking the sounds of words in reverse and, in the cipher or emissary he has come to call Blind Faith, spoke the first five verses of the Gospel according to St. John, while walking backwards at the bottom of the central escalator. We can know this to be true but still find it impossible to believe, prisoners of our eyes' seeing and our ears' hearing. The man strives to remain at a still point in a turning world; time turned against itself unfolds, until he stops walking and, standing still at last, is carried to the final elevation. The end, accompanied by Handel's climactic *Zadok the Priest* is really the beginning in this comical but unprecedented work.[6]

Hymn shows Wallinger exploring sentimentality, a necessary subject for anyone interested by innocence. Standing on a box on Primrose Hill, holding a balloon printed with a picture of himself as a boy and again dressed formally as the emissary Blind Faith, he breathes an oxygen/helium mixture from a cylinder. He sings 'There's a Friend for little children/ Above the bright blue sky', a Victorian hymn designed to bring comfort when the prevailing rates of child mortality carried off another infant. The helium — the thinner air of the heavens — gives his voice a high-pitched, childish tone; youth-time is comically figured by an adult. (As

we have seen, Wallinger used images of himself as a child in a painting as early as *The Bottom Line* 1986.) In *Hymn*, menacing his own childhood with a candied version of heaven, his motives remain mixed. Perhaps, behind the bafflement that cultural artefacts such as the hymn provoke, and the sense of innocence decidedly lost or laughed at, is the ghost of a child's question about mortality carried into adult life.

Prometheus, the third part of the video trilogy Speaking in Tongues, began as part of an installation with several elements and multiple references: automatic double-doors triggered by the viewer, a room put through a ninety-degree turn, giving the viewer a god's eye view of an electric chair, and a tubular metal structure made to the Vitruvian dimensions of the artist. The structure functions as a constant buzzing bell, but the circle is not complete; at the base a movable element closes the electrical circuit. The buzzing continues as long as the circuit is not broken by viewer-intervention; the principle is that of the wobbly metal line found not so long ago at fêtes and fairs, rigged up in reverse. For the performance aspect of the work, recorded on video and originally projected over the doors, the artist was seated in the electric chair barefoot in order to sing Ariel's song from *The Tempest*:

> Full fathom five thy father lies;
> Of his bones are coral made;
> Those are pearls that were his eyes:
> Nothing of him that doth fade
> But doth suffer a sea-change
> Into something rich and strange.
> Sea-nymphs hourly ring his knell:
> Ding-dong.
> Hark! now I hear them,-Ding-dong, bell.

It was sung in a falsetto voice but is played at a slow speed, which lowers the pitch into a strange, sonorous sea voice – and then at the end, the tape is suddenly rewound at high speed to become a shriek. The figure's body is by this process punished into a jerking likeness to electrocution. Repetition is built into this work as perhaps it is not in the others mentioned, and the viewer/witness of these repeated mock-executions is likely to feel both menaced and responsible. Self-punishment is also implied. There is more than enough for an interpreter in the Prometheus myths – the punishment for theft of fire from the Gods and the fashioning of mankind from clay – and in *The Tempest*, but broadly the piece reflects on the paradoxes of creativity. The force and beauty of the words of the song, their ability to function almost as an aesthetic credo, survive the process of repetition and the severe framing in legalised and theatricalised death, the fetish of certain systems of justice.

There is yet another element to this work which I want to pursue as it leads back to a Blakean dynamic: the involvement of contraries. The seated figure has tattooed across his knuckles the words LOVE and HATE; large photographs of these appeared on either side of the chamber in the original installation. The creativity that survives, then, is the product of inner division, just as the Fall represents a division within God. A homage to *Night of the Hunter*, Charles Laughton's sole film as director, is also involved and the claims of this reference are irresistible. The film casts Robert Mitchum as a fake preacher who preys on widows; he inveigles himself into the life of the widow of a man he met in a condemned cell, in order to pursue her children who know the secret of where some stolen money is hidden. On his knuckles are the tattoos Love and Hate; he likes to tell the story of 'left hand, right hand, the tale of good and evil...'. And yet there is a terrible sense that he might believe his own false claim to a relationship with God; his religion is 'something me and the Almighty worked out between ourselves'. Desire is something that both he and the rescuing force for good in the film, played by Lillian Gish, are disturbed by. He is shown attending a performance by a stripper – the men are silent and orderly, as though in a mission, and we get the first sight of those tattooed knuckles. Yet he tortures the widow he marries for her legitimate expectations on their wedding night, and sleeps in repression's nightdress. The good and evil antagonists are shown as mythically intertwined, almost as two contrary states of the human soul; towards the climax, they sing an unearthly duet. The fake preacher, if an avatar of Blind Faith, is a most worrying one.

The character of Blind Faith has more recently been photographed in south London locations as a cross-legged penitent seated before a school named for St.John the Divine – his cardboard sign reads 'teach us to sit still'; as the sole presence of a trinity of standing figures drawn onto a cement wall, as though facing an execution squad; and levitating with the aid of a mirror, a trick learnt from the comedian Harry Worth. Upside down, like a black bat, he is also shown haunting Shelley's grave, which it turns out is lettered with the words of Ariel's song. These works are titled *The Word in the Desert* 2000, and continue the quest for finding the upside-down and the wrong way round in situations proximate enough; for keeping alive some sense of both the world's secular incompleteness and the violence of some forms of art, faith or even humour that would claim or assume the powers of healing too definitely.

The humour induced by a recent video work, *Fly* 2000, is quite different in its helplessness, but is underpinned by serious questions of how space is constructed. Observing that a fly had died but remained somehow stuck on the windowpane, Wallinger trained a camera on it for a day and presents edited extracts from its afterlife. Other flies, of various sizes, encounter the fly; some investigate their dead cousin, most ignore it. Aircraft and birds pass by – they appear the same size as the fly, which is placed at the centre of the image. The soundtrack consists of multiple radios and the TV droning on. This absurd premise is affecting because there is a formal idea at play that finds eternity in an hour, infinity in a speck of decay. The subject of the

death of a fly was for Blake's poem *The Fly* an occasion for strong faith, a recognition of divinity shared by the small scales of creation as by the large: 'Am not I / A Fly like thee / Or art not thou / A man like me?' Wallinger has framed his fly in the centre – at the vanishing point. It inhabits the place of honour of Renaissance picture-making, which organises and produces the illusion of infinite space extending on all sides of the image, the front plane of which could finally be regarded as a window on the world.[7]

Classical perspective has been a preoccupation of Wallinger's since the major series *School* 1989, which replaced the vanishing points of blackboard drawings of the architecture of his own school with lightbulbs, from which the construction lines radiate. (There is also a temporal peculiarity in these works by virtue of the strangeness of schools when empty, the sense that you are doing something excitingly wrong by being there; Wallinger has also mentioned the role played by our dreams of school.) These remarkable works cannot be allied easily to a critique of one-point perspective or indeed pedagogy and authority, on which they don't editorialise. Unlike Blake's schoolboy from the *Songs of Innocence*, the one who loved to rise of a summer morn but hated to sit at school ('Under a cruel eye outworn'), it is conceivable that Wallinger extends sympathy to teachers, entrusted with the duty of care, as well as pupils. The difficulty of imagining a space 'outside' the powerful symbolic order of classical perspective is established; as though we could just turn the light off on such a powerful paradigm and walk away. The related philosophical problem is how reason (portrayed in cartoons by lightbulbs turning on in the mind, not off) can come to know its own blind spots and distortions without giving up on its difficult aspiration for a proportional view, outside the vanities of culturalism.

The uninflected language and formal clarity of this work carries through to *The Four Corners of the Earth* 1998, which attempts to disorganise spatial perception by projecting slides of an ordinary globe onto four flat circular canvases arranged in the corners of a room. The circular projections are matched precisely to the canvases. The four 'corners' are large areas identified as substantially above the geodetic mean (by about 120 feet) though, somewhat incredibly, three are covered by the oceans. Art galleries are places where one can expect to encounter this kind of information without warning, and to not always know whether to believe it. The corners prove difficult to approach because the viewer's shadow eclipses the small four-cornered sun of the projectors. This ruins any attempt to enjoy the illusion from the ideal viewing position; to do that, the single eye one would use would have to leave behind its corporeal housing and shrink to a mathematical point, or perhaps a singularity, an infinitely dense speck. Wallinger is more often spotted reading poetry or David Thomson's *Biographical Dictionary of Film* than popular science primers, but *The Four Corners of the Earth* does aspire to drag the sorry old globe's unforsaken history into a new perceptual arrangement; along with our clumsy bodies that no longer sustain any geometrical harmony with the spheres (though

the canvases conform to the Vitruvian proportion of the artist). Liberal hopes that what is central and what peripheral can be rethought are neither pilloried nor effected by this work; they are blotted out by shadow as we approach the political detail, leaving us stuck with an uncomfortably godlike view of human affairs. If that account still sounds close to a misplaced sincerity about what art can achieve, it does I hope make clear the implication of frustration in this work (as in a severer work like *Object Lesson*), which is discovered nested within an arrangement at first seeming to offer the sublime. It is the spectator, not the world or its corners, that this work of art mirrors.

Cave 2000 contrives a similar kind of exploded space, but reinjects a more emotive and painterly subject, boxing. It reconfigures a round of a professional boxing match, which played to an audience of a few hundred in a leisure centre. Both image and sound are slowed to quarter speed, stretching three minutes into fourteen. The four views from each side of the ring are shot square on, with ropes dividing the image in half, rather formally, and are projected onto the interior walls of an enclosure approximately the same size as a boxing ring. The sound is extraordinary: the doom-laden bell, the clap from the referee emerged from his neutral corner, the metallic click of what must be the ropes. Features are rendered indistinct. While the slowed movements of the boxers reveal a balletic grace – reminiscent of Francis Bacon's use of Muybridge – the sound of the crowd, whose individual voices are heard at boxing matches, becomes like that made by wild animals. The estrangement of image and sound forces the viewer/witness to reconnect them, and, of course, one is waiting to catch the sound of the thuds as glove connects with flesh.

Cave is a proxy experience, via coloured moving shadows on walls, of a sport many people never get to see for real. The title recalls Plato's allegory of the cave, in which prisoners, chained so that they cannot move, gain knowledge of the world only through observing the shadows cast on the wall by what passes outside the cave. They perhaps learn to connect the sounds and echoes they hear with the shadows of the figures that pass by. That is the image everyone remembers: the prison-house as an allegory of sight, and the journey out of it, the journey of the soul into the intellectual world. In fact the allegory ends by emphasising the ethical obligation of those who have attained knowledge to return to the cave and disabuse those chained within it of their false knowledge; it therefore entails not just rising into the blinding light of the intellectual world but learning to see in the dark too (*Republic*, 29, 514a-521b). Wallinger's *Cave* reconfigures some of these questions – notably the separation of images from sounds, which we must learn to connect anew. At the formal level, it continues the artist's quest for new perceptual arrangements, using some of the clarity of classical perspective against itself to contrive some genuine perplexity in the viewer about the position from which they see this reconfigured round of boxing – its aesthetic possibilities and grace, its mythic force and violence. And it is a quest for Wallinger to contrive such spaces, something

that arises from genuine and continuing uncertainties about human wishes as well as the politics, beliefs and entertainments they frame for themselves.

Ian Hunt

1 MARK WALLINGER is INNOCENT is a text work by the artist that can be reconfigured at any size, for instance a billboard or a fly poster.

2 Paul Gilroy, *Between Camps: race, identity and nationalism at the end of the colour line*, Allen Lane, 2000, pp.151-2.

3 Wallinger had an early encounter with the poverty of satire while working in Collet's bookshop, a major socialist emporium, rolling up hundreds of copies of a poster headed 'Gone With the Wind', showing the heads of Ronald Reagan and Margaret Thatcher montaged onto figures engaged in a nuclear embrace. This period also provided examples of the deformations entailed in some oppositionalist stances, and an unwelcome real-life encounter with right-wing violence when some National Front supporters attacked the shop and its staff in 1986. See Wallinger's contribution to *Who's Afraid of Red White and Blue*, ed. David Burrows, Article Press, University of Central England, 1998.)

4 picture a procession with dignified
 horses pulling coaches containing
 famous people in wonderful costumes
 kings and queens and princes and princesses
 adored by a loving country
 the bandsmen striking up the national anthem

 envisage a pageant with fine
 horses drawing coaches bearing
 noble people in exquisite clothes
 kings and queens and princes and princesses
 applauded by a loving public
 the soldiers playing the national anthem

 imagine a cavalcade with noble
 horses drawing carriages bearing
 distinguished people in elegant clothes
 kings and queens and princes and princesses
 loved by a proud country
 the cavalry playing the national anthem

5 See Jon Thompson's essay in *Mark Wallinger*, Ikon Gallery/Serpentine Gallery, 1995, and Andrew Wilson's in *Mark Wallinger: Lost Horizon*, Museum für Gegenwartskunst, Basel, 1999.

6 The artist has located reversed footage in a Charlie Chaplin short. To ensure that the swing of an axe could land impressively close to a foot with no danger to the actors, the gag was paced out and acted in reverse.

7 See Erwin Panofsky's essay *Perspective as Symbolic Form* [1924], Zone Books, New York, 1991.

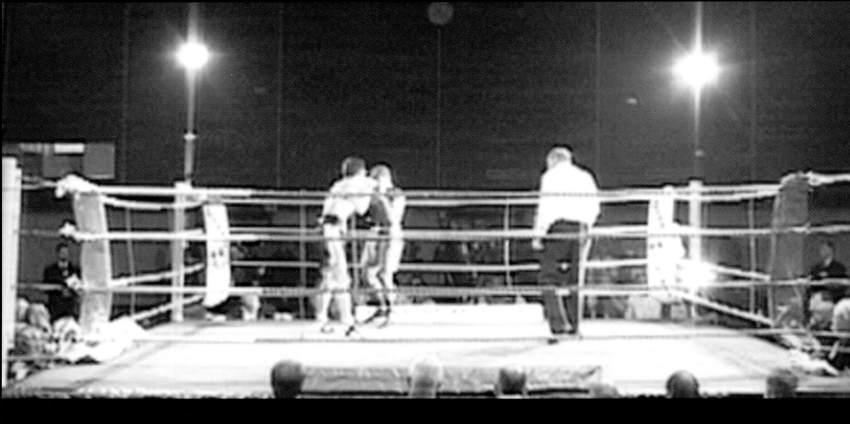

Cave, 2000 (details)

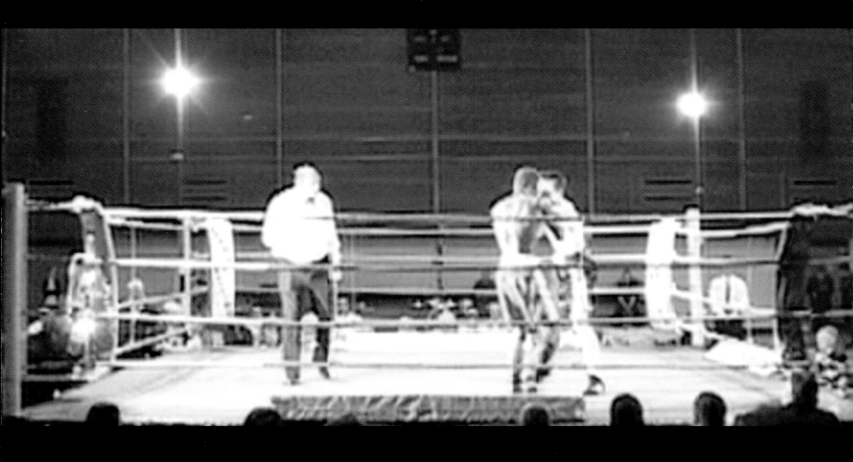

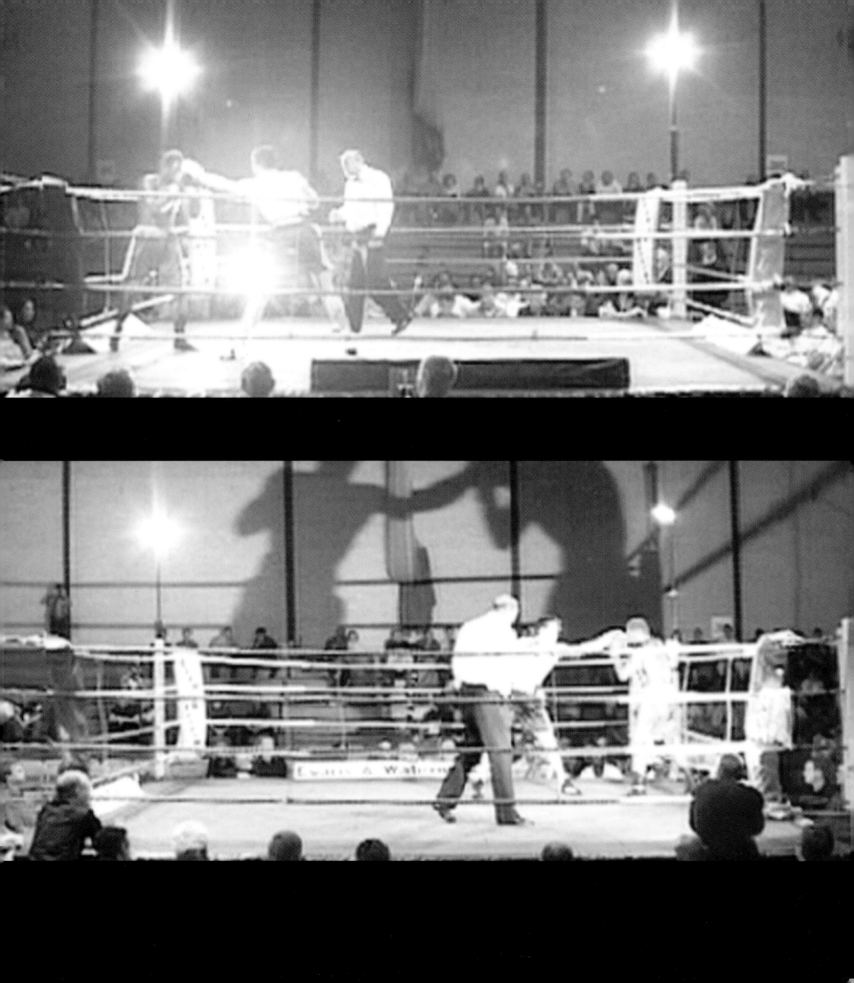

Beyond Belief
Mark Wallinger's *Ecce Homo*

Sometime in the autumn of 1999, amidst the aged and dignified public monuments that the subjects of the British Empire erected in and around Trafalgar Square, a new public sculpture appeared: a life-size statue of a man. Unlike the many larger than life sculptures of ordinary men and women, who by some gallant deed or accident of birth were considered worthy of celebration, this new figure looked distinctly out of joint among the monuments of London. And after the millennium had been thoroughly celebrated the sculpture disappeared. The statue was Mark Wallinger's response to an invitation to make a public work for a plinth that had remained empty since 1841. The commission was also an invitation to take part in a competition of sorts, in which two other artists were to succeed Wallinger's statue with their own sculptures for the vacant plinth. In the original scheme of things it was suggested that the general public would vote either for one of the three commissions to take up permanent residence in the Square, or to have the plinth become a site for temporary exhibits. At the time of writing the debut of the third commission has been delayed and news of (and perhaps commitment to) the competition seems to have dwindled. It seems unlikely that the figure, entitled *Ecce Homo*, will reside permanently in Trafalgar Square, as Mark Wallinger might once have hoped. However, since *Ecce Homo*'s disappearance from London there have been reported sightings of the figure in other parts of Europe.

To be immortalised through a public sculpture is one way of surviving death. It is one way of communicating the importance of certain values, deeds and public figures to future generations. The most impressive monument left to the populace of London is Lord Admiral Nelson on his column who, close to the heavens, stares not at the ground below marked by the passing of London's inhabitants, but steadily into the future and eternity. It is unlikely that Nelson noticed the brief appearance of Mark Wallinger's *Ecce Homo* who neither stared into the future or at the ground below but instead kept his eyes shut. What's more Wallinger's figure is dressed only in a loincloth. Adorned with a crown of thorns and with his wrists bound behind his back, Wallinger's figure appears less than heroic. The Gospel tells us that this figure is Christ; a political prisoner and victim of religious persecution in the last abject moments before his execution. The title *Ecce Homo*, 'Behold the Man', were the words uttered by Pilate as he presented Christ for judgement; a phrase which has become synonymous with images of Christ crowned with thorns. And for Wallinger, one suspects, *Ecce Homo* is something of an allegory for persecution of all kinds, particularly when surrounded by the trappings of colonialism, nationalism, religion and commerce in the form of public monuments and grand buildings.

Ecce Homo brings together several themes that Wallinger has explored in his earlier work, such as a concern for the ideological edifices that secure the dominance of specific national identity, class structure or tradition. In the past, this has been an exploration that has often been both a materialist critique and referencing of cultural pursuits enjoyed by the artist. However, in Wallinger's recent work, it seems his critique has been tempered by more transcendental themes, as in the case of *Ecce Homo*.

In Trafalgar Square, Wallinger's Christ figure stood blindly on the edge of a stone base. He was perched on the very limit of his plinth, perhaps about to descend to the greasy pavement below: one jump or sightless step away from the profane world of ordinary men and women. The other statues watched this humbled, tortured man with disdain from above. On an adjacent plinth the imposing statue of George IV towered over the tourists who gathered below, whilst Wallinger's man-sized Christ figure only served to emphasise the grandness of his plinth designed to elevate and immortalise. And so Christ stood before the people in Trafalgar Square and perhaps before his fellow statues too, passively awaiting judgement, just like he did 2000 years ago at Pilate's side.

And we judged him. Did *Ecce Homo* belong on a plinth along with other immortalised souls? Why did he not look bigger? Did the Christ figure represent an ordinary man? And perhaps, as the mass of revellers celebrated the end of the second millennium in the Square, a few individuals might have looked up and considered the event they were commemorating, and then also thought about acts of unspeakable persecution, both past and present. They may have judged this apparition of Wallinger's vulnerable Christ figure to be a timely appearance.

Unlike Katharina Fritsch's *Yellow Madonna* installed in a Square in Münster in 1987, where a break in the crowd bustling through the Square would suddenly reveal a vision of the Virgin, an encounter with Wallinger's Christ is not a spectacular revelation. Instead, in Trafalgar Square, *Ecce Homo* stood aloft: a melancholic figure whose life-sized scale is perhaps not suited to the life of a grand sculpture or icon designed to outlive mere mortals. It was Boris Groys, the Russian art historian, who provocatively suggested that Christ was a Readymade; that is, both ordinary, (a mortal like any other man), and immortal, (a sacred and divine entity). For Groys, Christ has something in common with Marcel Duchamp's *Fountain*, which was once just an ordinary urinal but that now persists as an immortal icon. It has long been the case that Western works of art are considered extraordinary and immortal, but it was Duchamp who demonstrated this fact. Groys' point is that the modern work of art, after the birth of the (pseudo-religious) Readymade, is that which places an ordinary object, image or experience in the context of art where its duration becomes extraordinary, transcending the mortal fate of flesh and bones. And, it could be added, the choosing of a Readymade is an act that plays with faith.

In the past, Wallinger has shown an interest in the strategy of the Readymade. Wallinger's own *Fountain* is a hosepipe that runs through an exhibition space and ejaculates a never-ending

stream of water into the world beyond the gallery. But more relevant to *Ecce Homo* is another public work by Wallinger, *A Real Work of Art*; a race horse that the artist part-owned and that could be described as a Readymade: a horse given the status of an authentic work of art that raced in the Sport of Kings. *A Real Work of Art* was, in one sense, an investigation of beliefs and values and *Ecce Homo* extends that investigation. What would we do if a real work of art bit us on the nose; what would we do if we really stood before Christ. Would we know them if we saw them? Would we believe it?

With *Ecce Homo* the issues of belief and duration turn on the question of whether the man represented is an ordinary mortal or not. (It should be noted that he doesn't look like any image of Christ one might be familiar with. Not much like a figure of universal suffering but a very ordinary man indeed.) In raising this issue of belief *Ecce Homo* questions the concept of immortal works of art, particularly public sculpture, not just in relation to the ideological values they express but in relation to their longevity. Public sculptures, for the main part, repress any notion that the ideas and values that they have been cast from could, or even should, become obsolete or disappear. The public sculpture hopes to live beyond the time of mortals. And it is the way that *Ecce Homo* subtlety raises these issues, through the depiction of an ordinary man about to die, but whom one may or may not believe will live forever (in Spirit at least), that makes Wallinger's piece significant. In this sense, the persecuted and tortured figure of *Ecce Homo* was a question mark that punctuated Trafalgar Square's stone and bronze figures embodying the beliefs of a nation.

This marking out of a question by *Ecce Homo* challenges all public works of art and the legitimacy of their permanency, even that of *Ecce Homo* itself. It was Marcel Duchamp, begetter of the Readymade, who enigmatically claimed that a work of art has a life span of fifty years. An aesthetic smell, as he termed it, that lingered for only a short while. And when the smell disappeared, the work from which it emanated would be quite dead. He probably wasn't thinking about public works of art but perhaps they too should be thought of as having a limited life span. Perhaps before anyone tries to erect another public sculpture or something similar, they should remember the humiliated and humbled figure of Wallinger's *Ecce Homo*. Behold the man, surrounded by doubt, awaiting the judgement of the question, 'Is he ordinary and mortal or will he live forever?'

David Burrows

He that
eateth my flesh,
and drinketh my
blood, dwelleth
in me, and I in
him

John 6:56

Ecce Homo, 1999

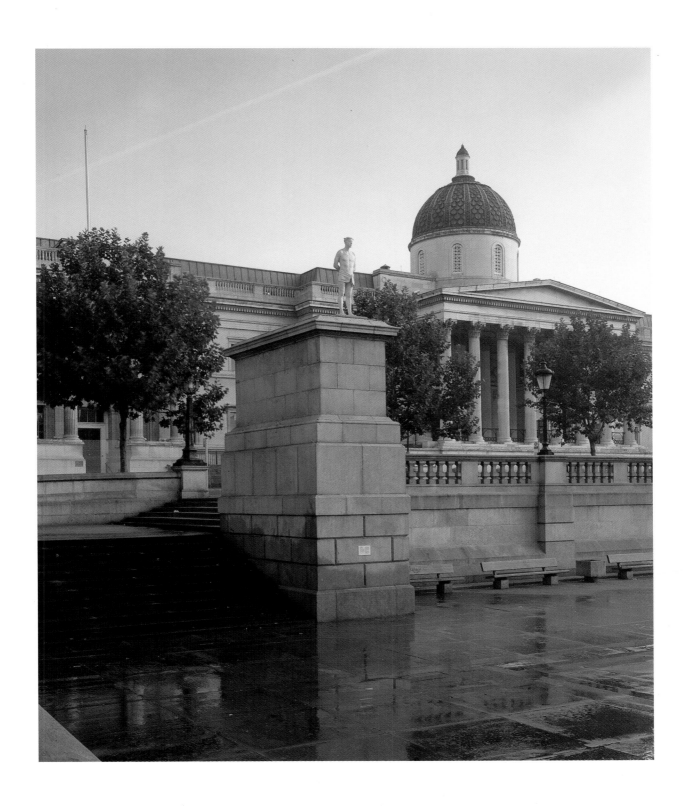

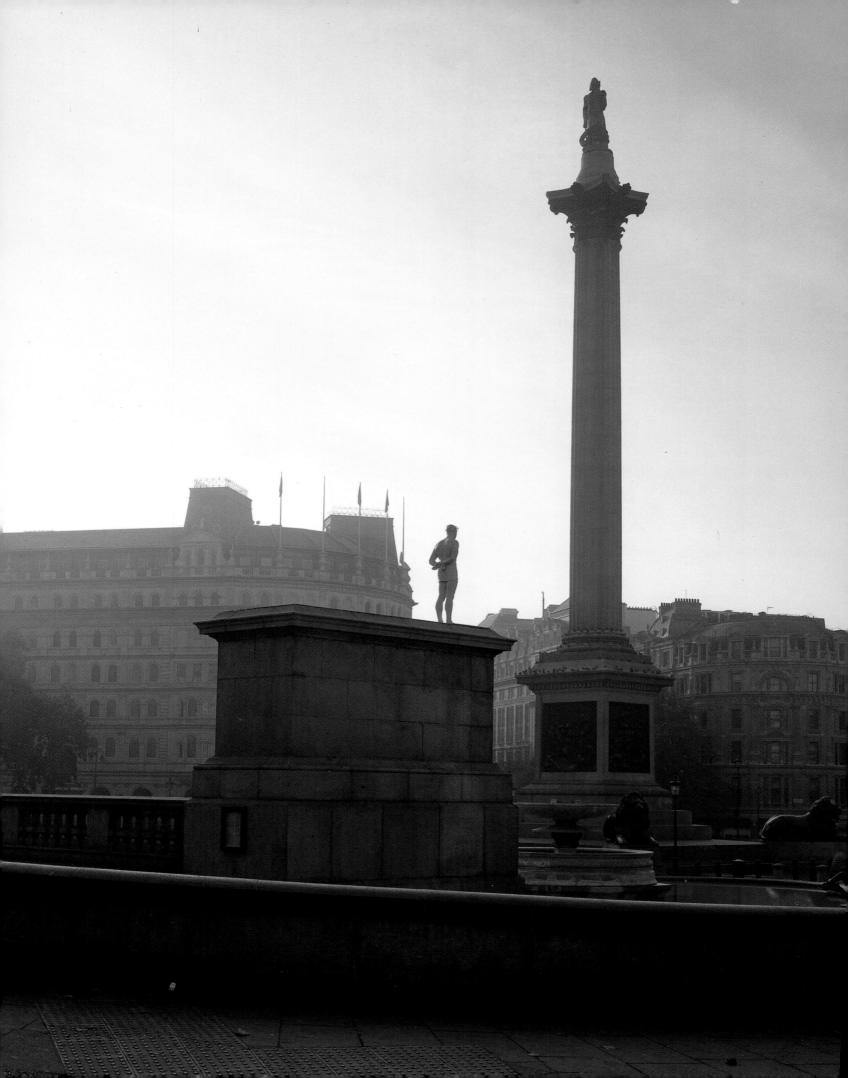

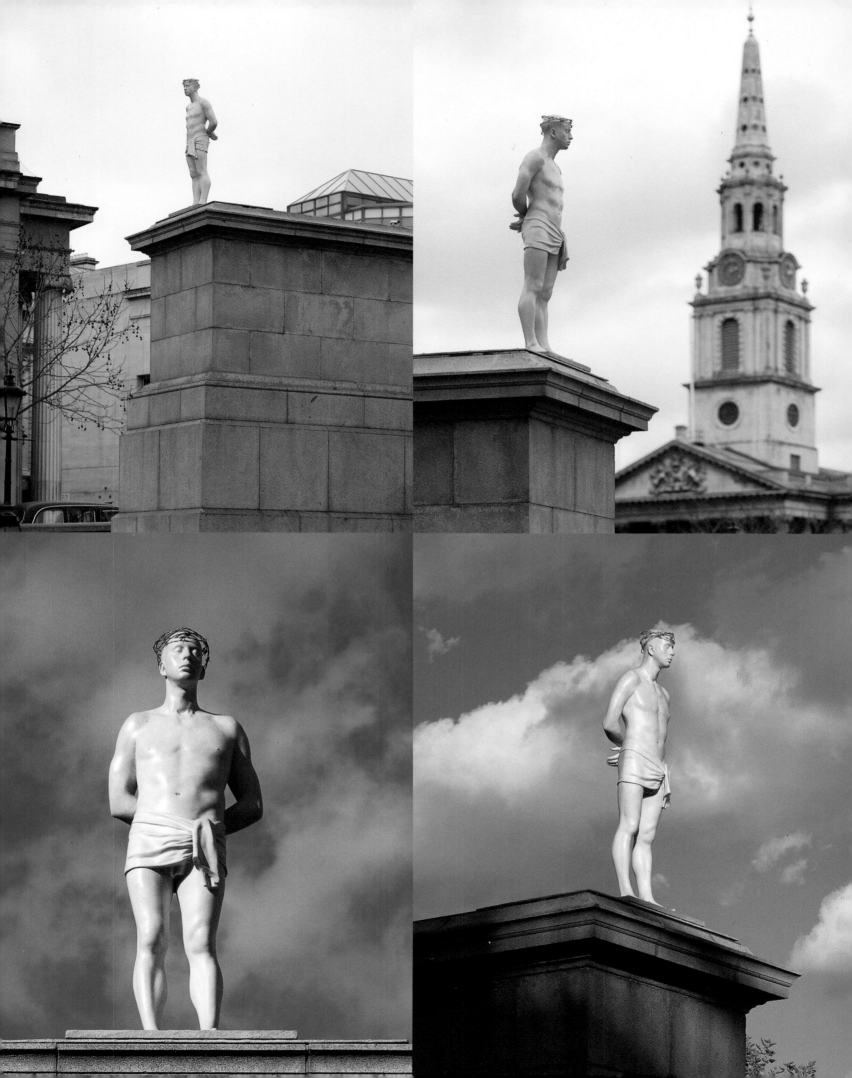

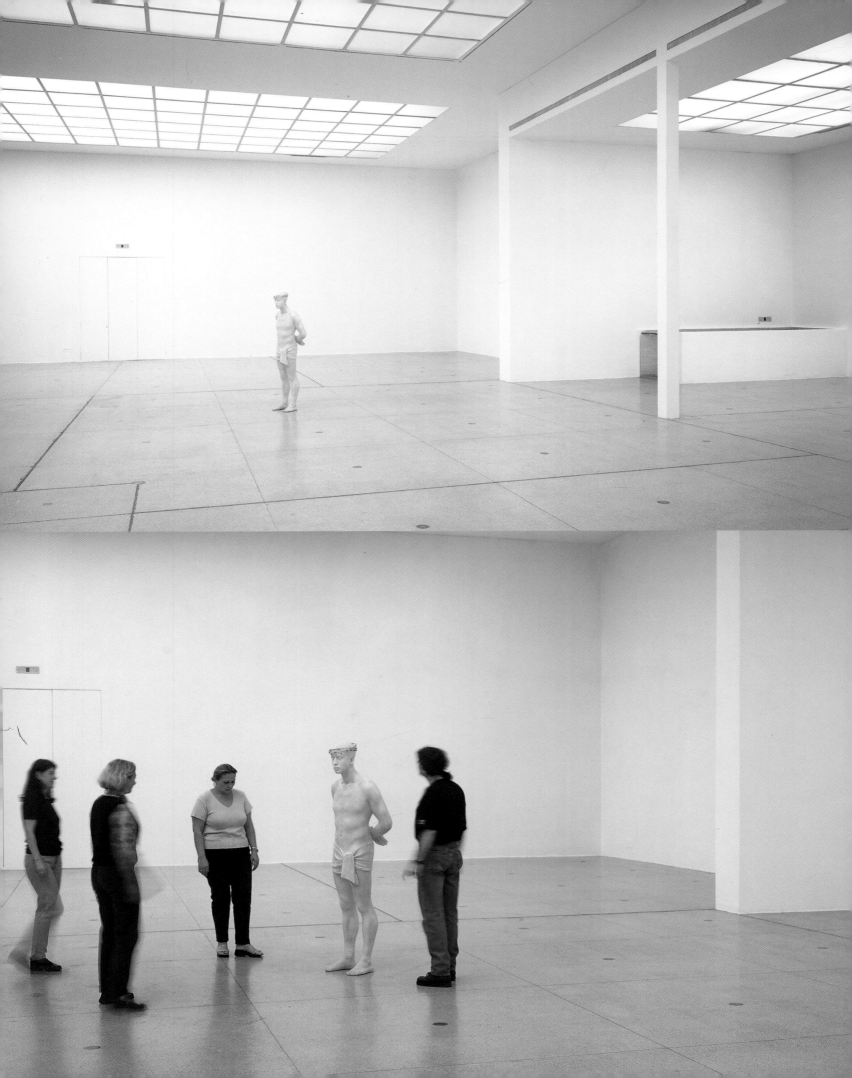

Natural Selection, 1988

RIGHT: **They think it's all over — it is now**, 1988

English and Welcome to it, 1987

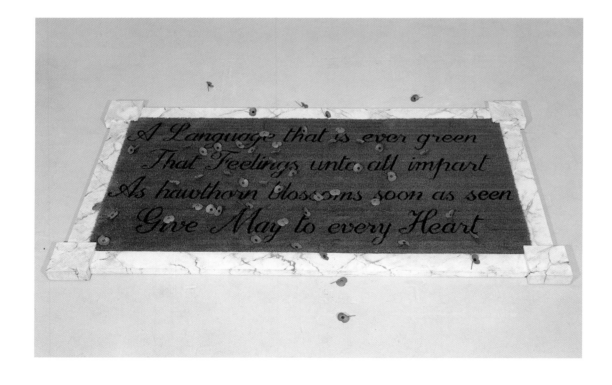

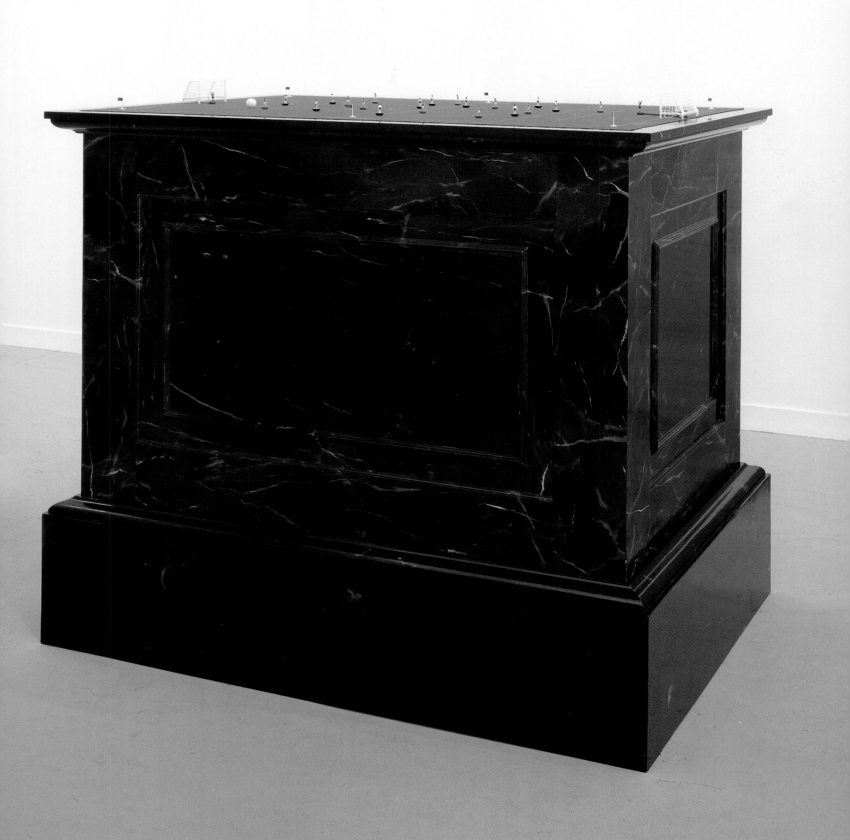

A Model History, 1987

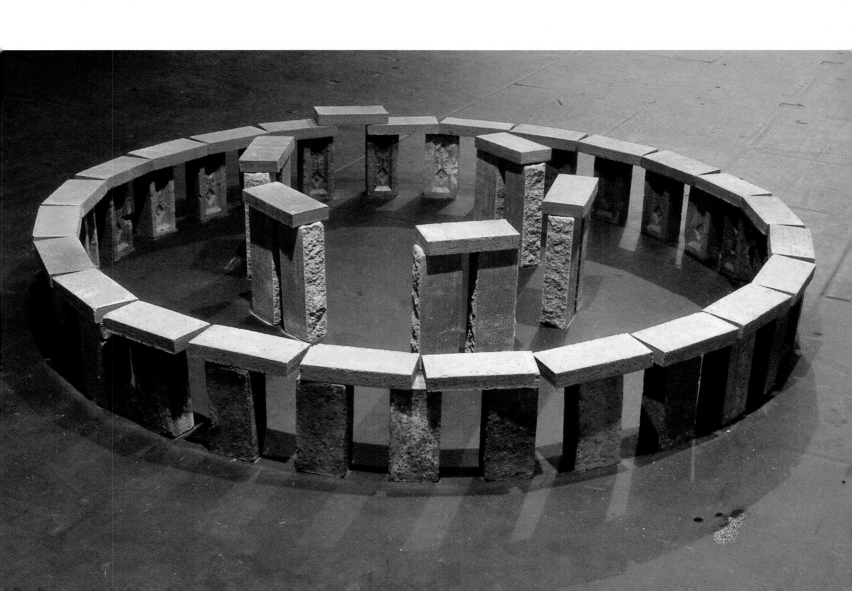

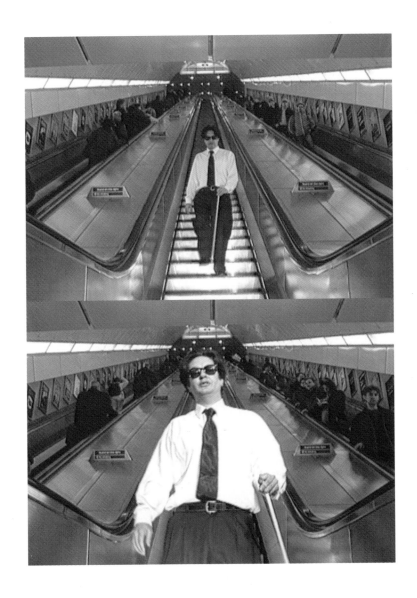

Angel, 1997

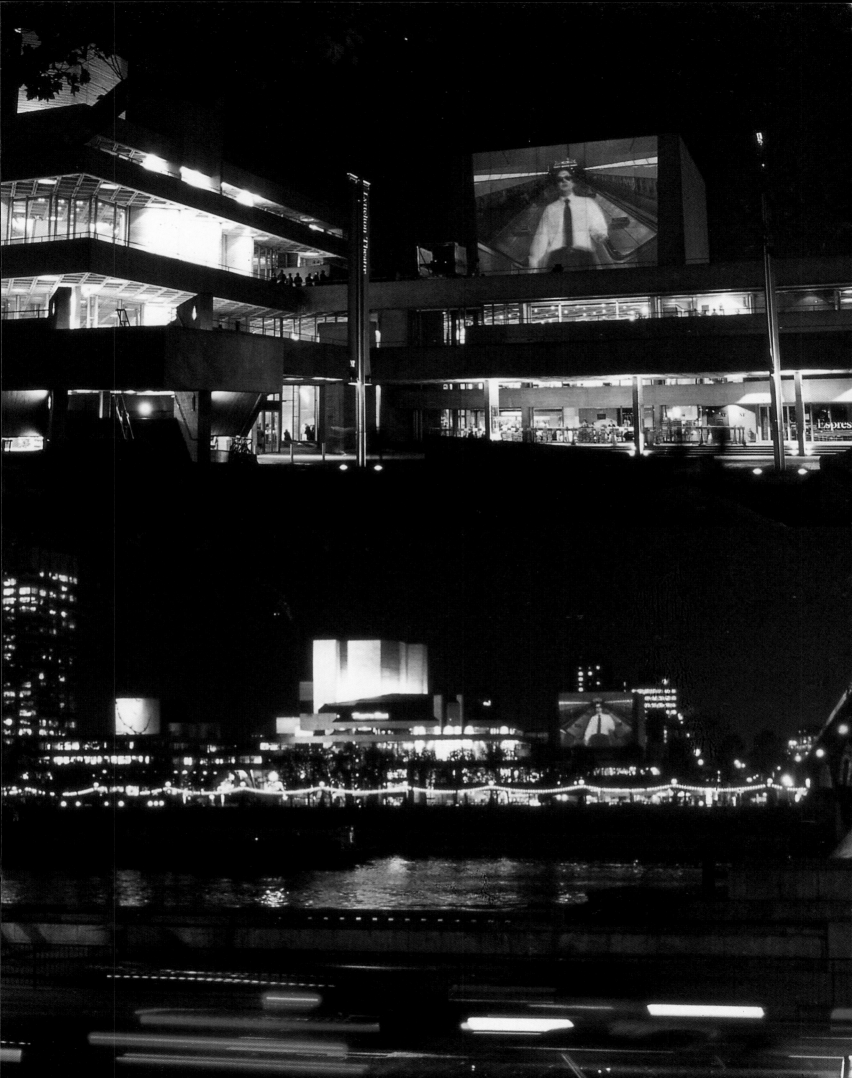

School (Assembly Hall), 1989

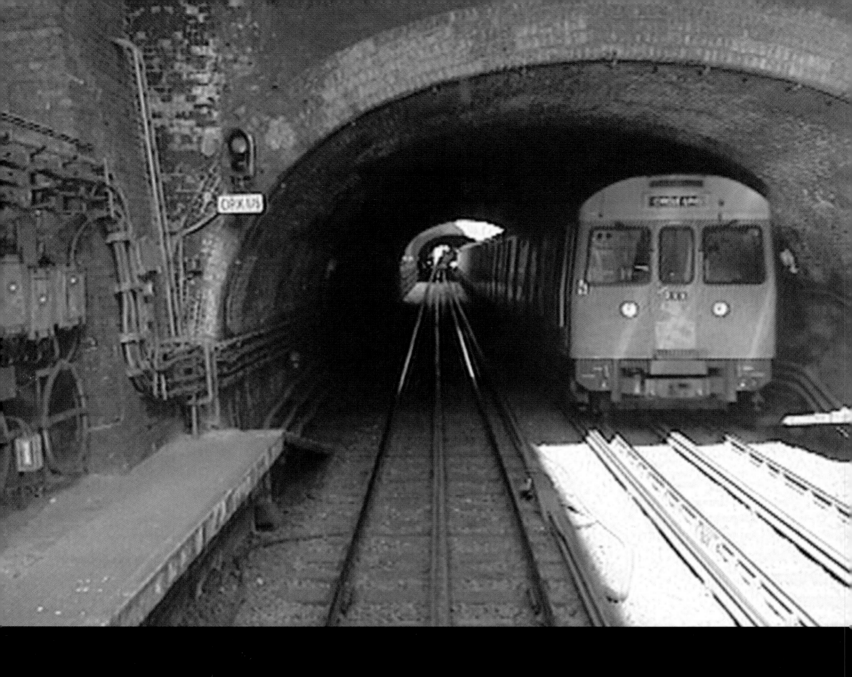

When Railway Lines Meet at Infinity, 1998 (details)

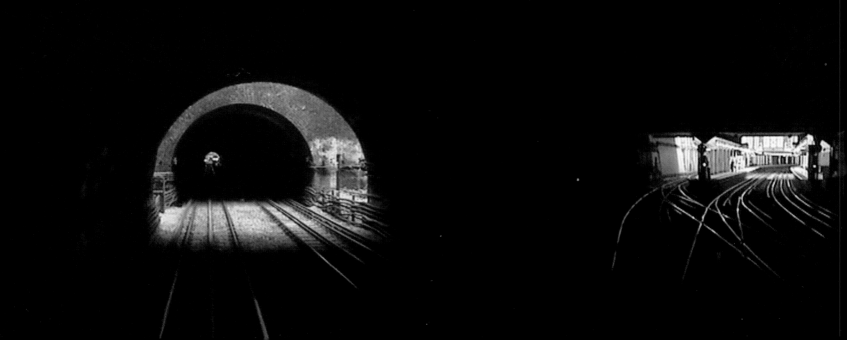

My Little Eye, 1995

RIGHT: **Genius of Venice**, 1991 (detail)

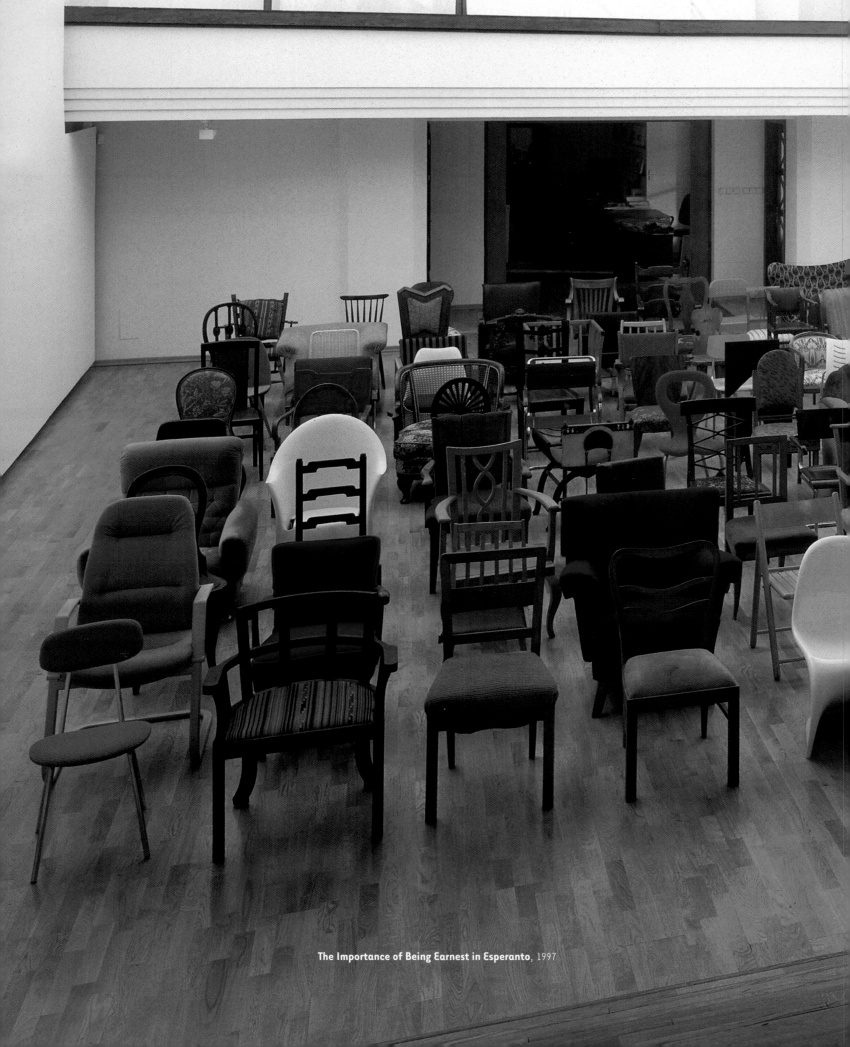

The Importance of Being Earnest in Esperanto, 1997

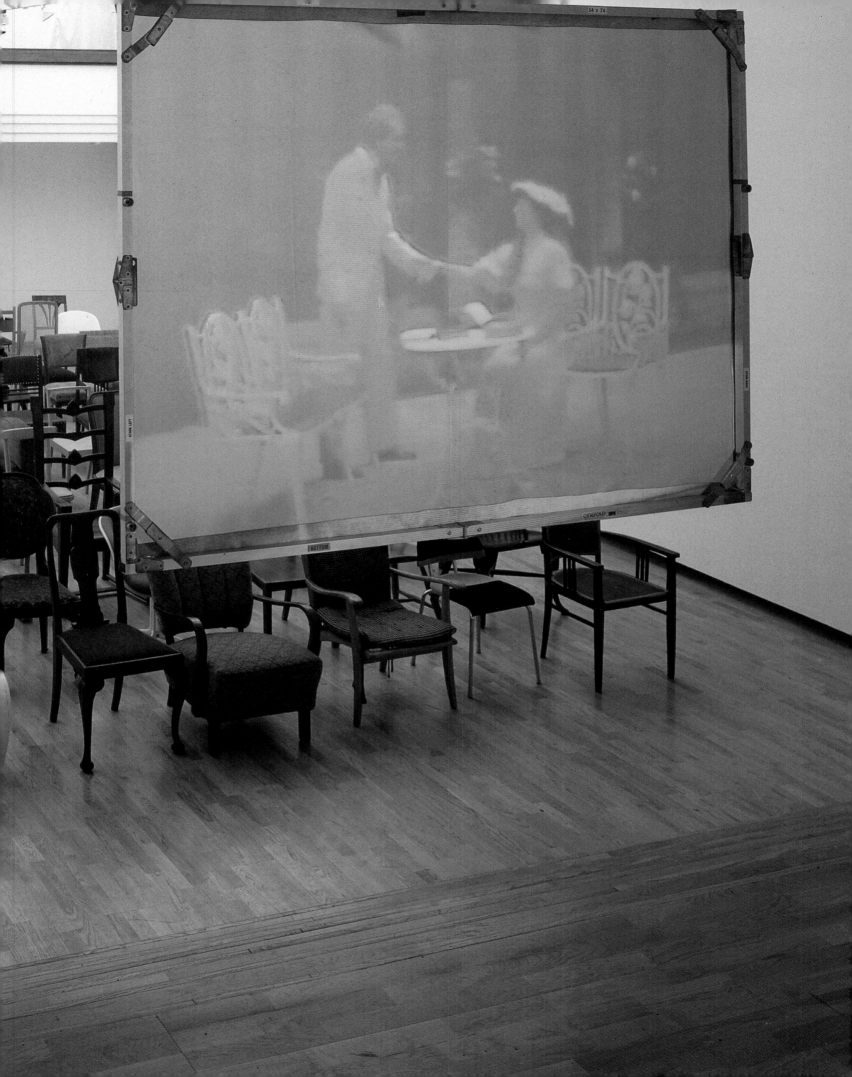

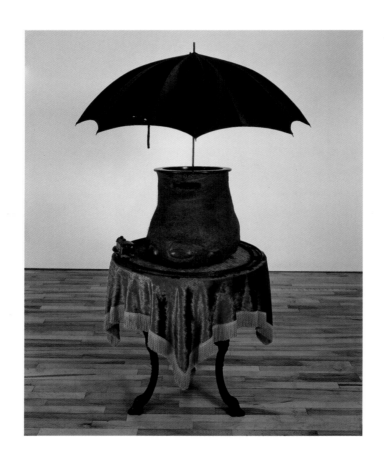

Booty, 1987

Oh no he isn't, oh yes he is, 1993

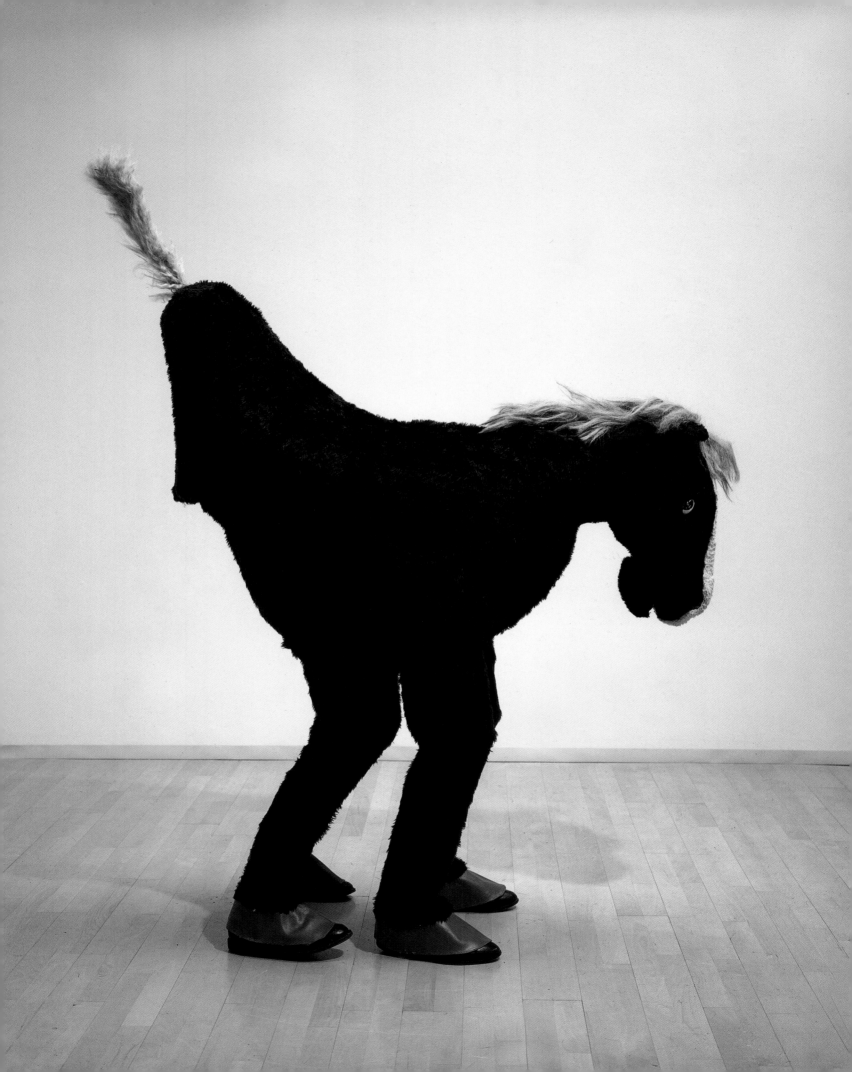

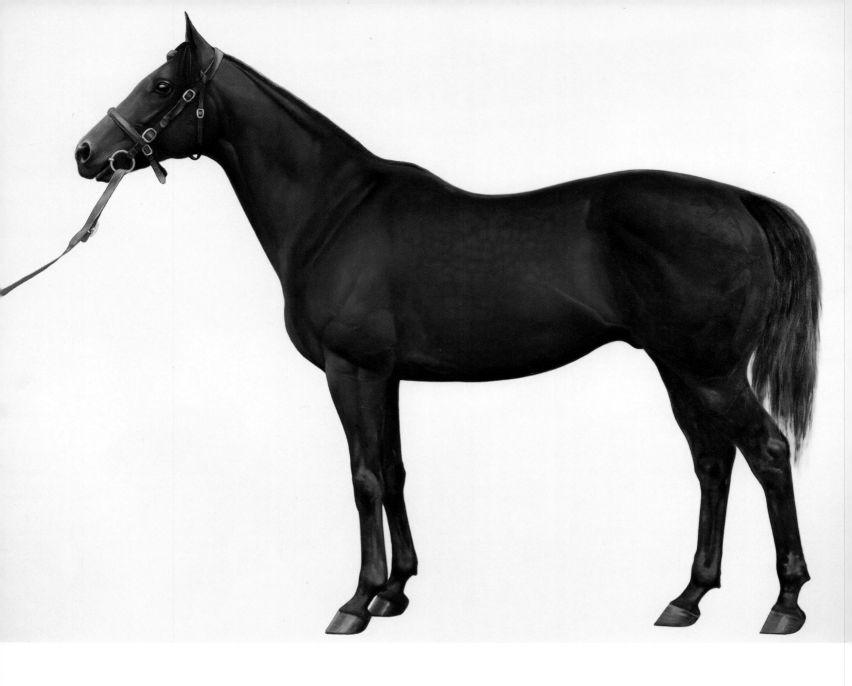

Race, Class, Sex (Shareef Dancer), 1992 (detail)

RIGHT: **Fathers & Sons (Blushing Groom/Nashwan)**, 1993

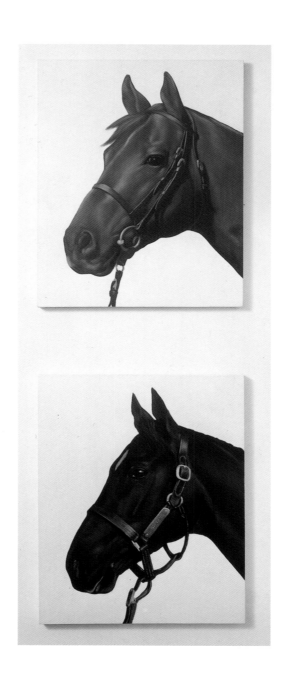

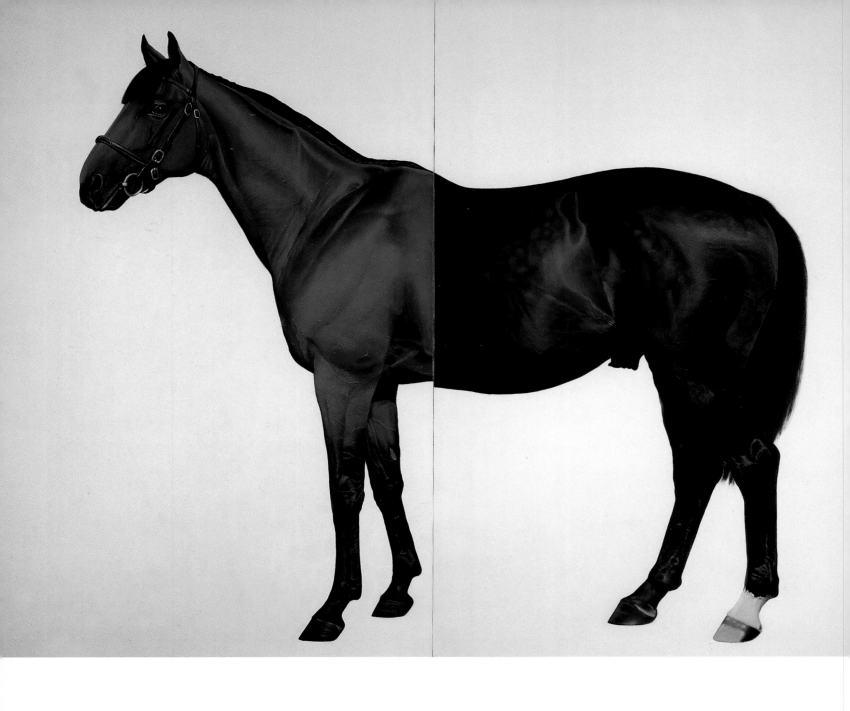

Half Brother (Jupiter Island – Precocious), 1994-5

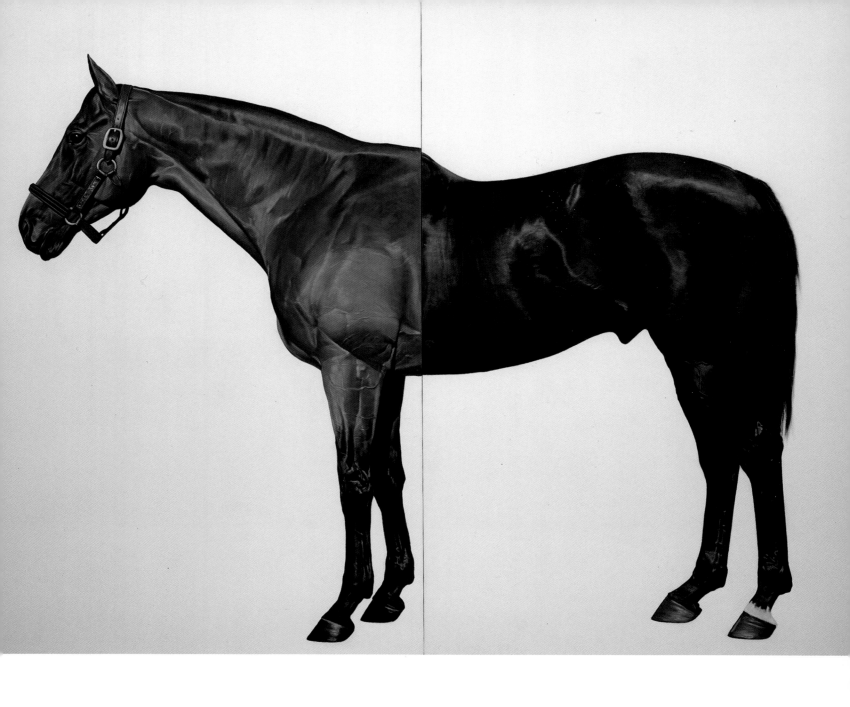

Half-Brother (Exit to Nowhere – Machiavellian), 1994-5

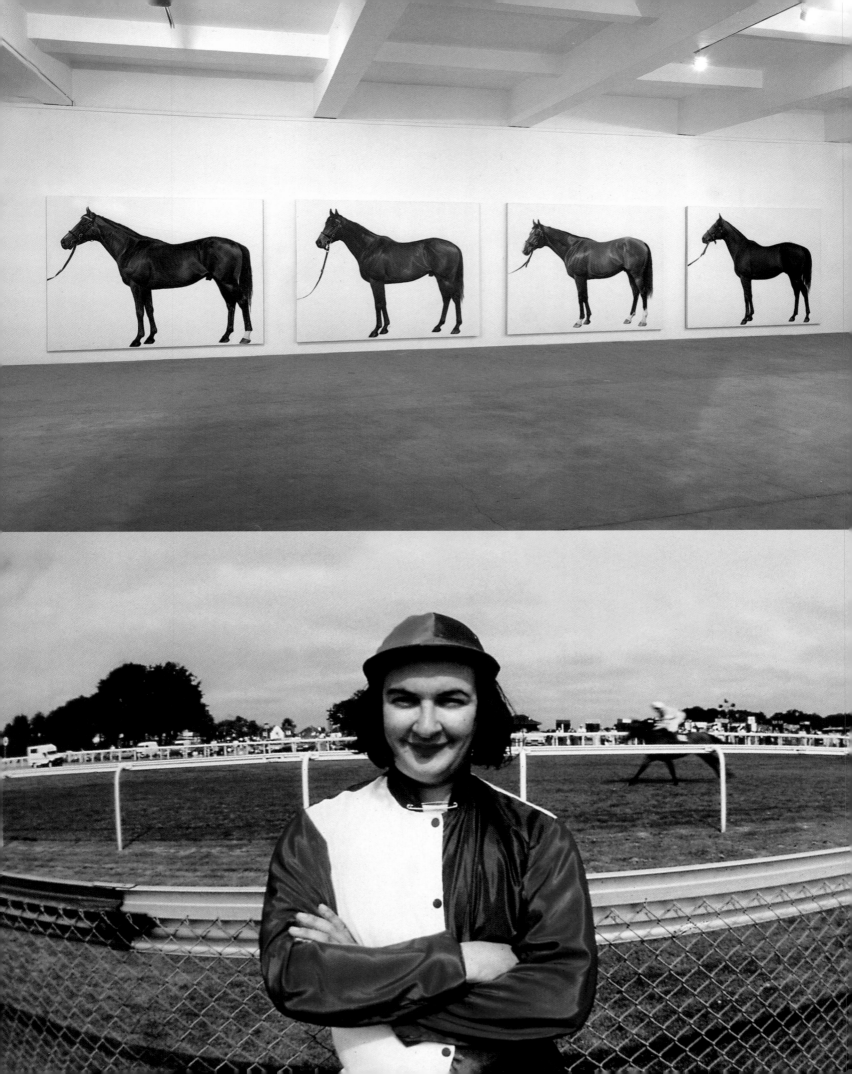

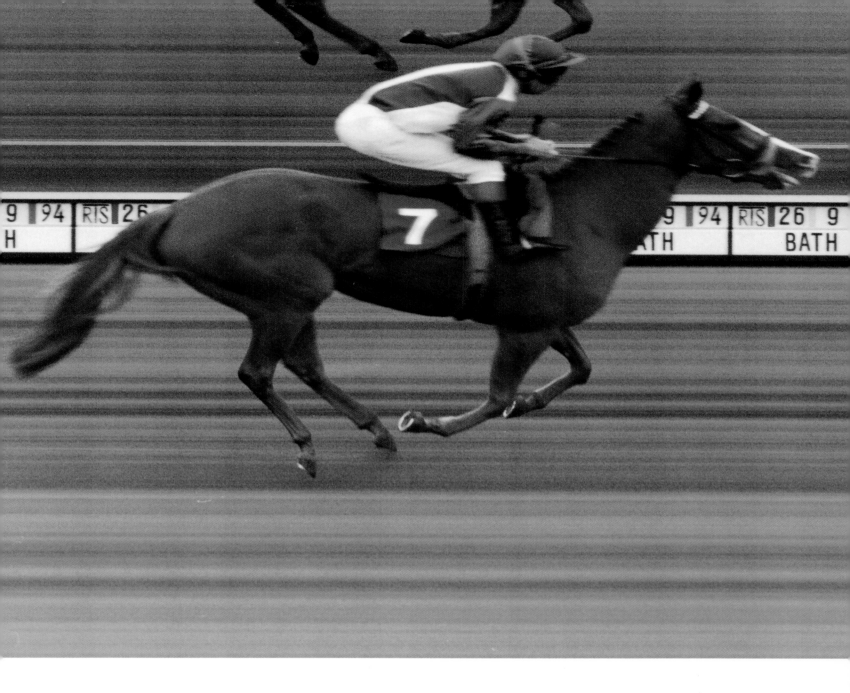

A Real Work of Art, 26 September 1994, 1994

LEFT:
Race, Class, Sex, 1992
Self Portrait as Emily Davison, 1993

Prometheus, 1999

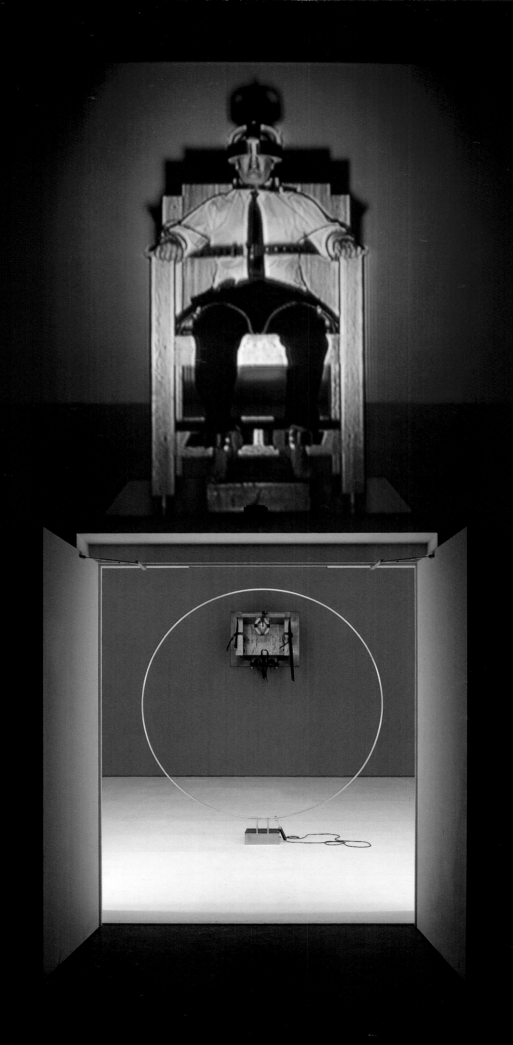

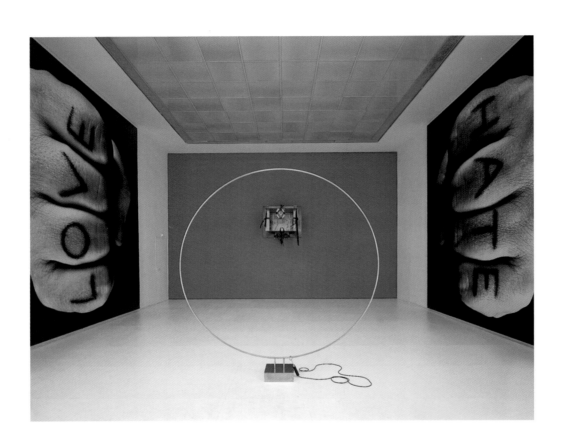

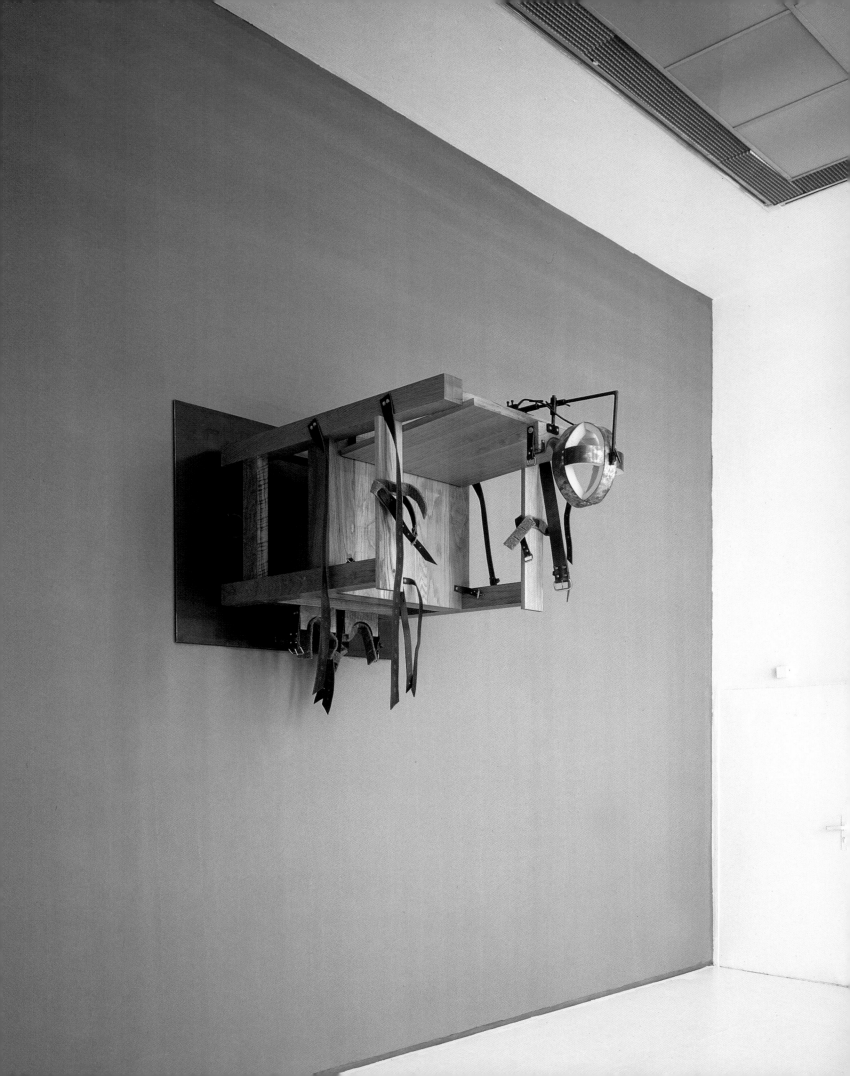

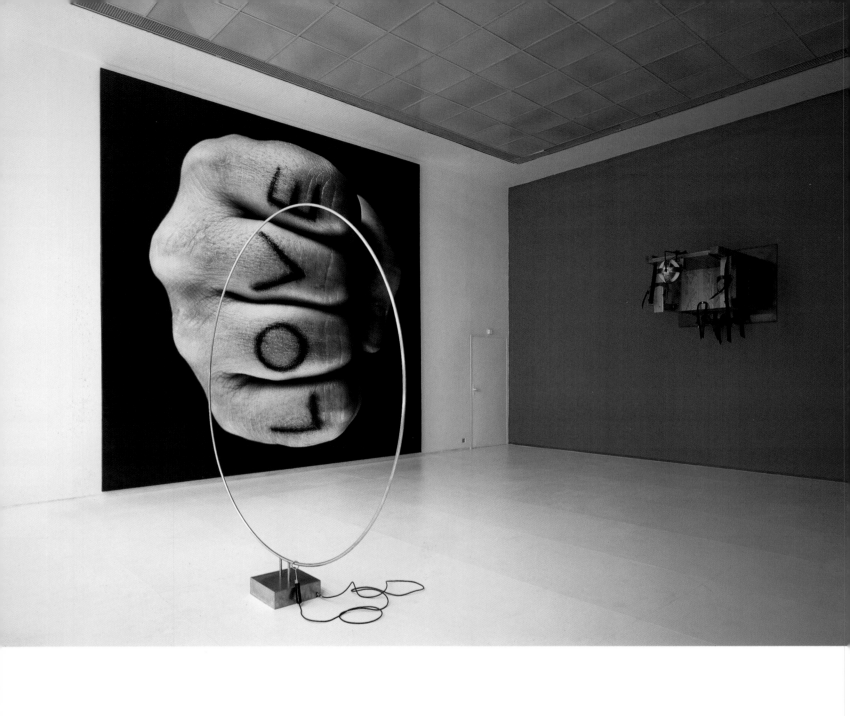

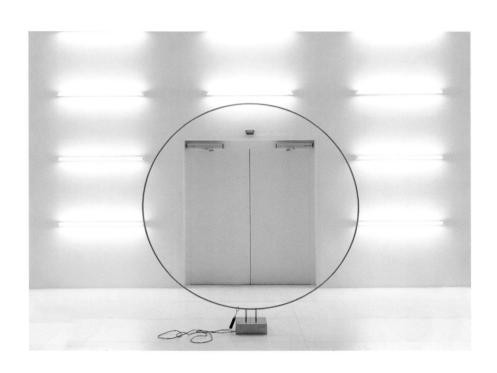

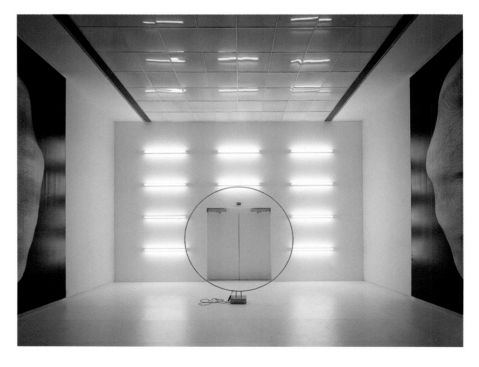

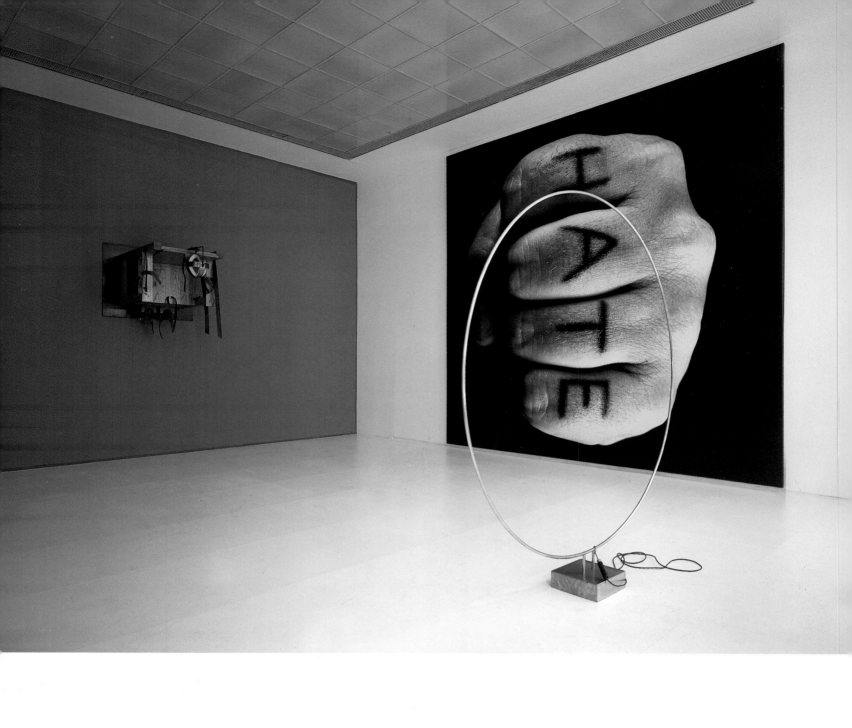

LEFT: **Fly**, 2000

The Four Corners of the Earth, 1998

**Upside Down and Back to Front,
the Spirit Meets the Optic in Illusion**, 1997

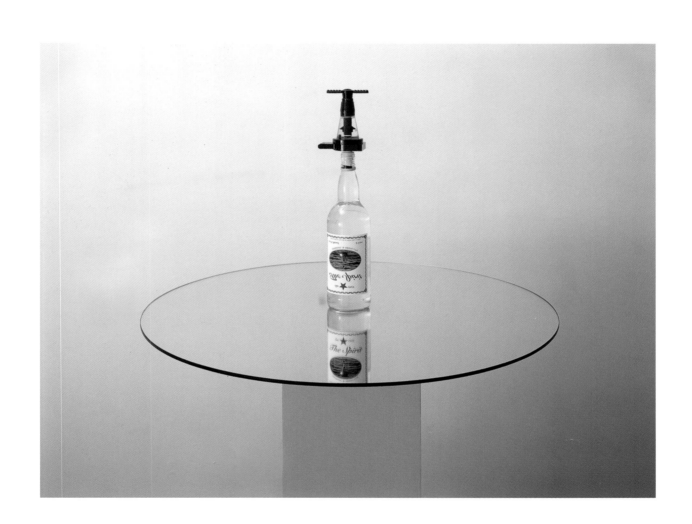

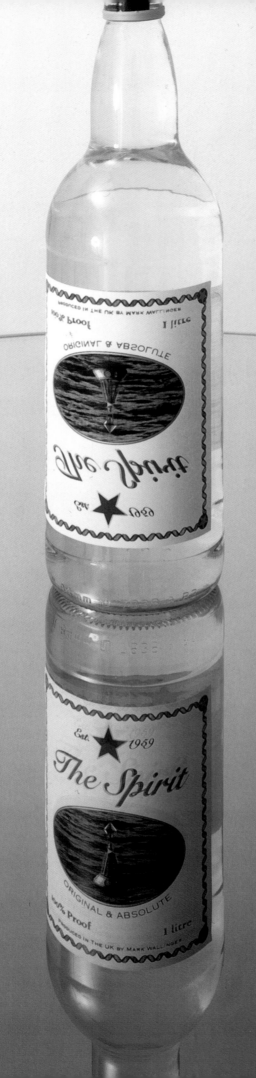

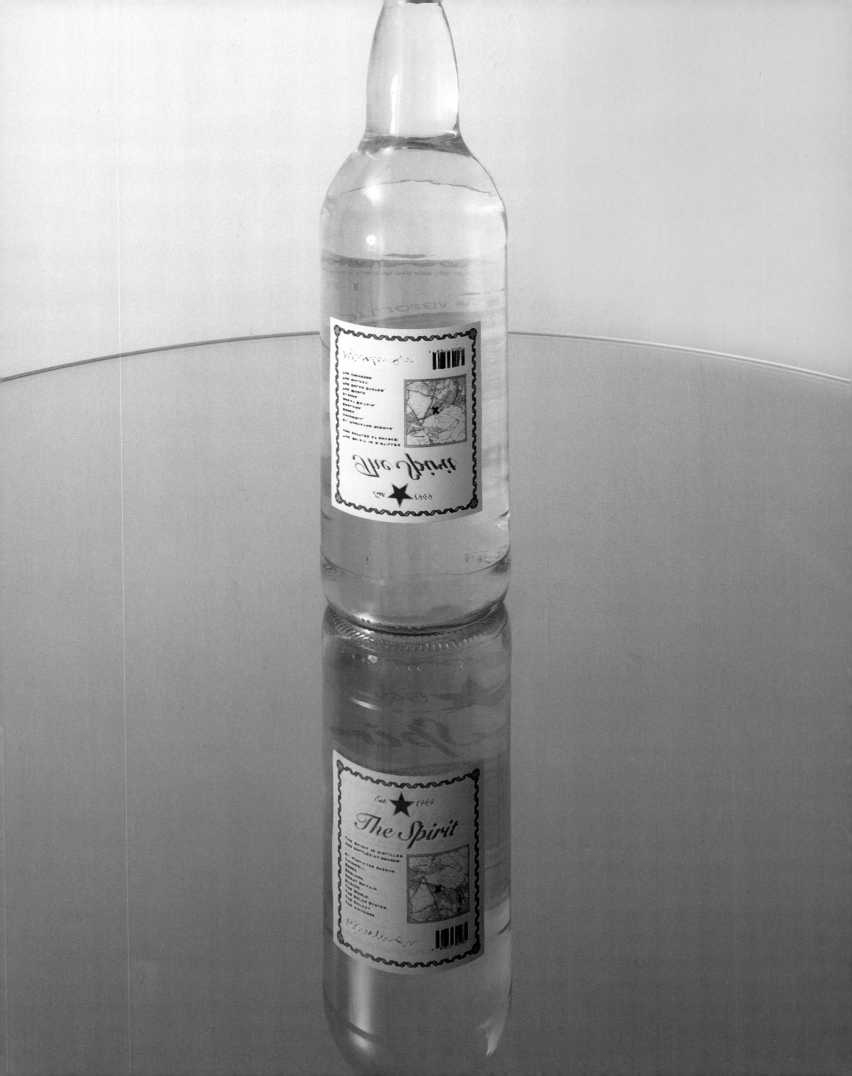

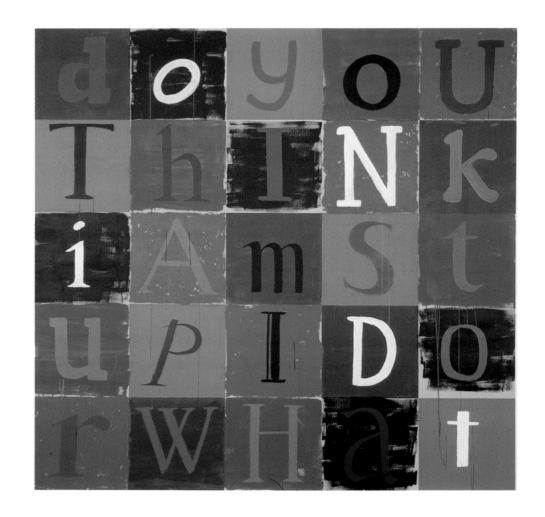

Q3, 1994

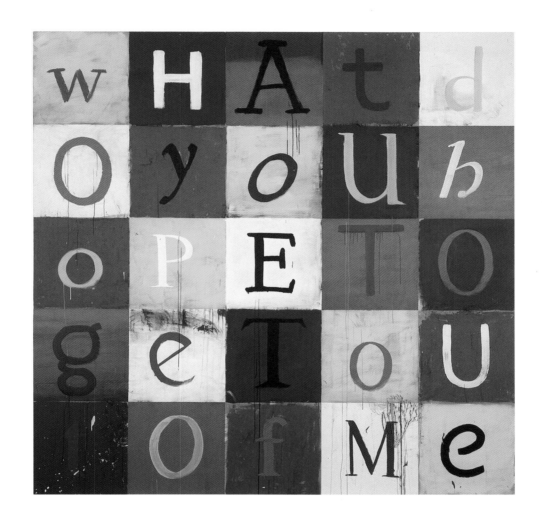

Q4, 1994

Hymn, 1997

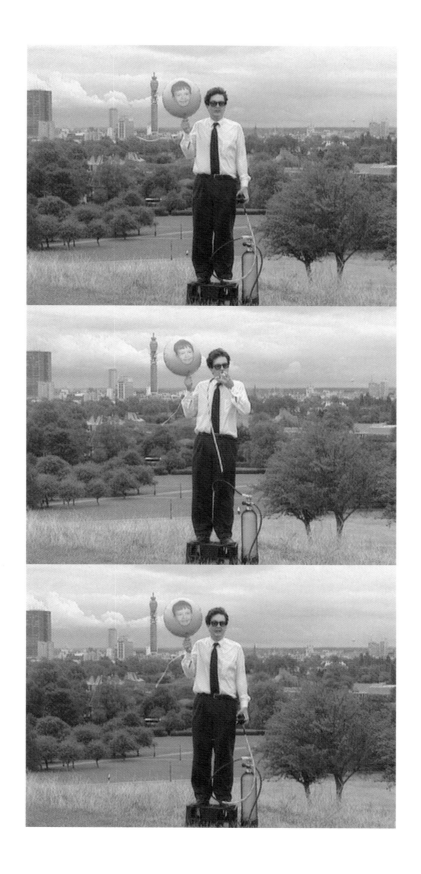

We Know What We Like, 1990

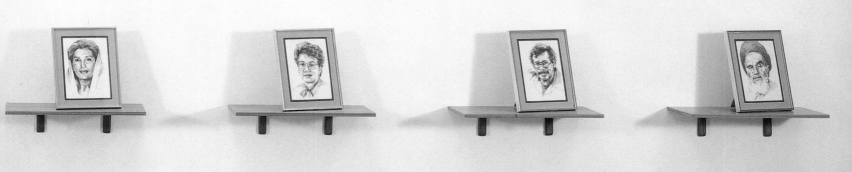

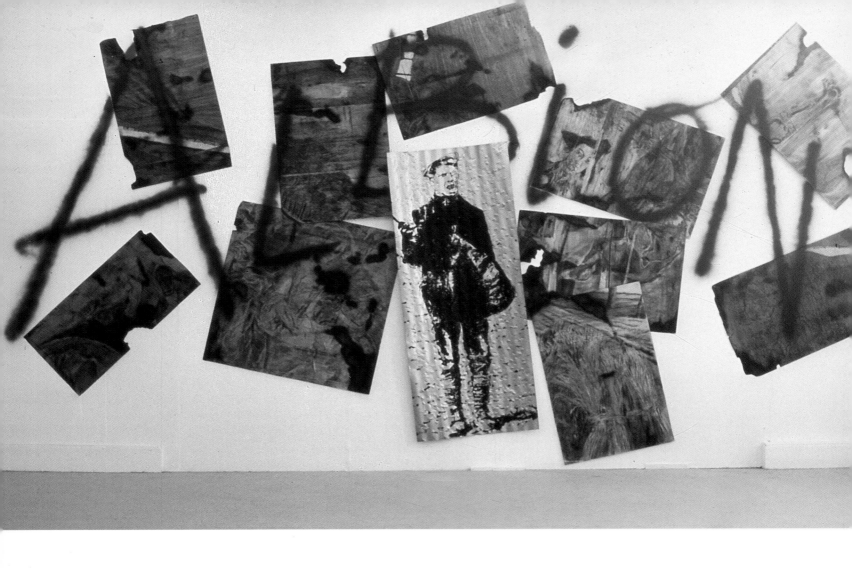

Where there's muck, 1985

Common Grain 5, 1985

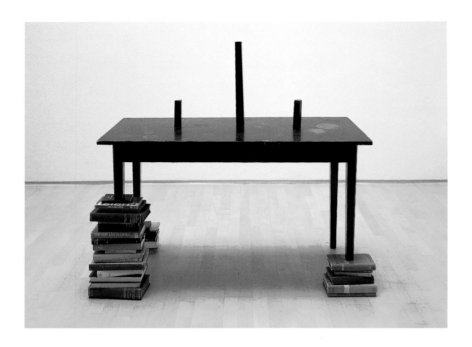

Autopsy, 1996

National Trust, 1985

Oxymoron, 1996

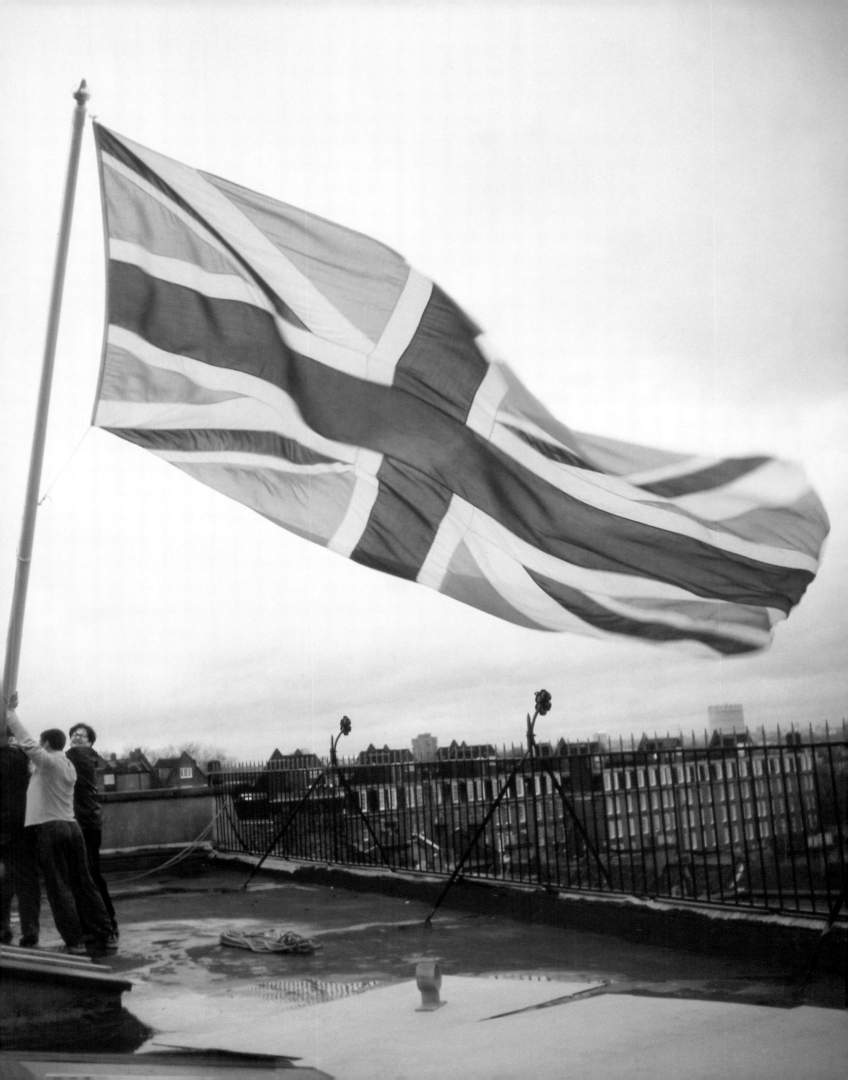

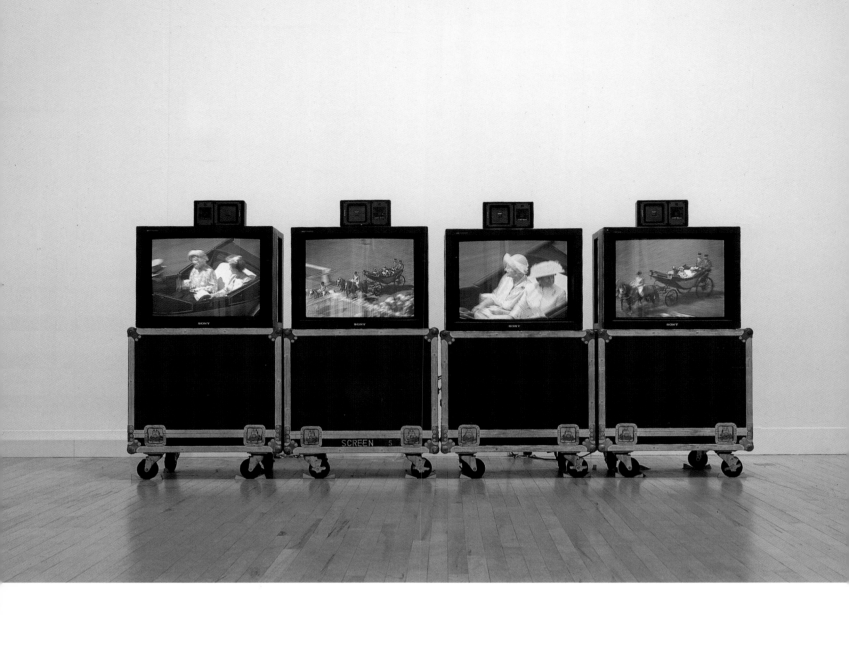

Royal Ascot, 1994

Tattoo, 1987

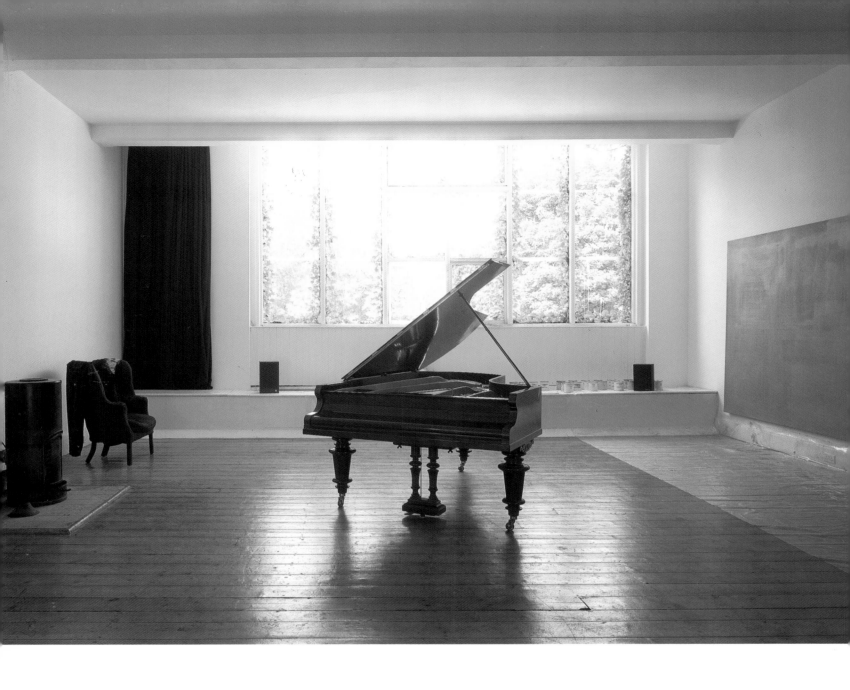

Untitled, 1994

Seeing is Believing, 1997

I
NT
HEB
EGIN
NINGW
ASTHEW
ORDANDTH
EWORDWAS
WITHGODA
NDTHEWOR
DWASGOD

Regard A Mere Mad Rager, 1993

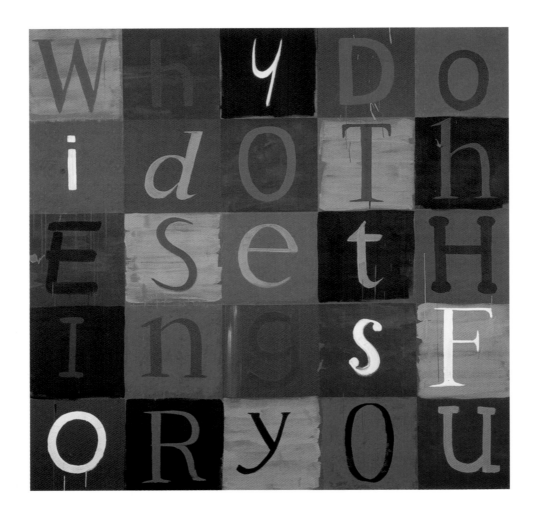

Q5, 1994

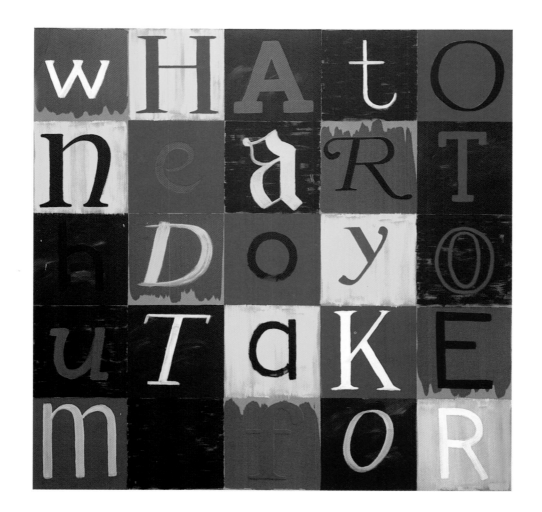

Q6, 1995

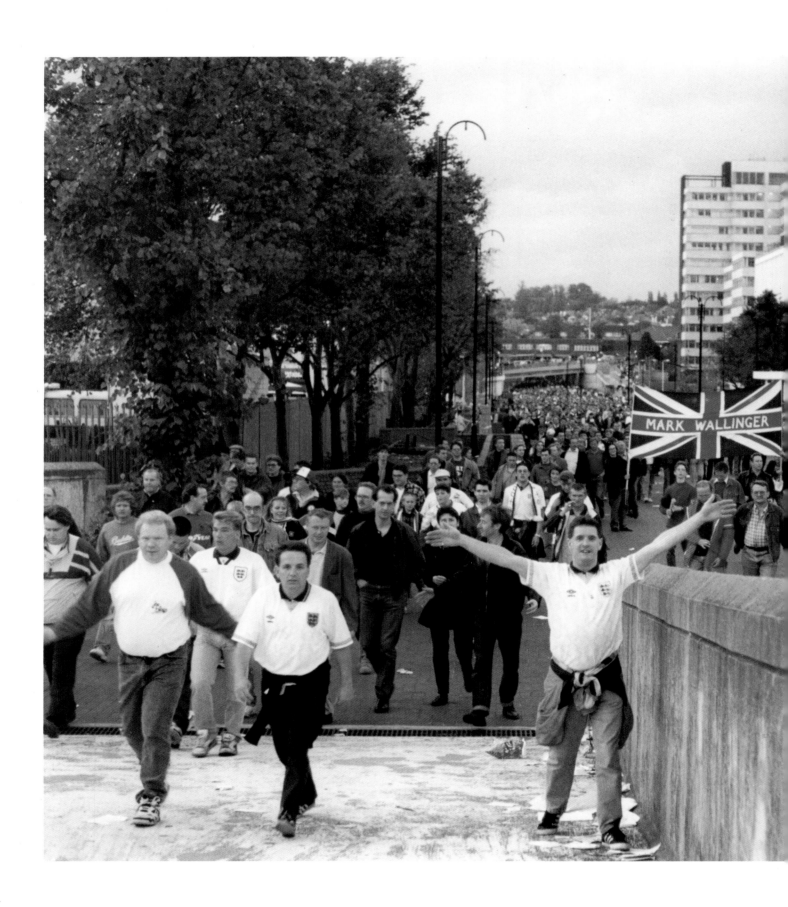

Mark Wallinger, 31 Hayes Court, Camberwell New Road, Camberwell, London, England, Great Britain, Europe, The World, The Solar System, The Galaxy, The Universe, 1994

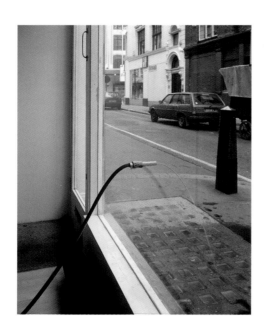

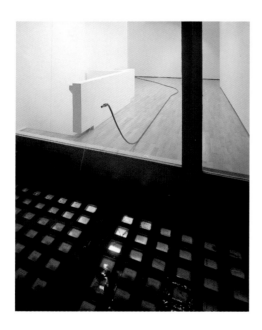

Fountain, 1992

Within the image, the following text appears:

Thomas Day pinx 'Hare Hall in Essex the Seat of John Arnold Wallinger Esq.' W. Angus sculpt g.V.6

Stately Home, 1985

OVERLEAF: **Threshold to the Kingdom**, 2000

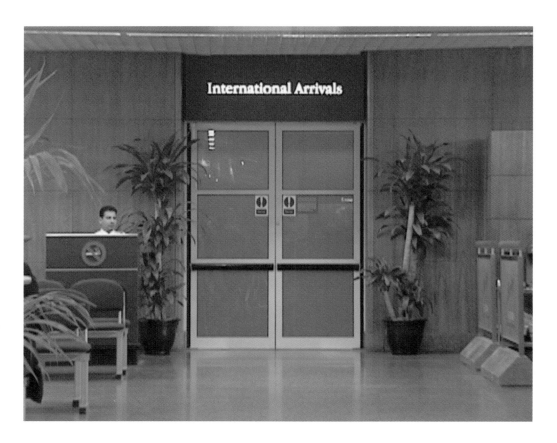

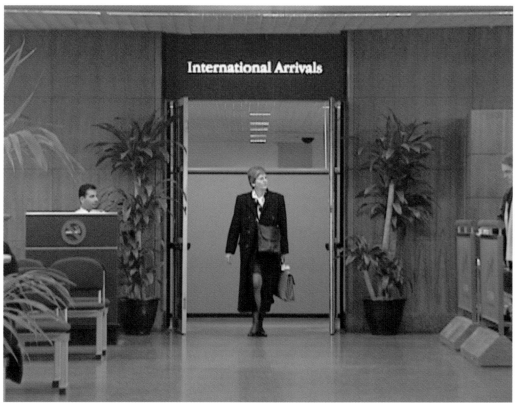

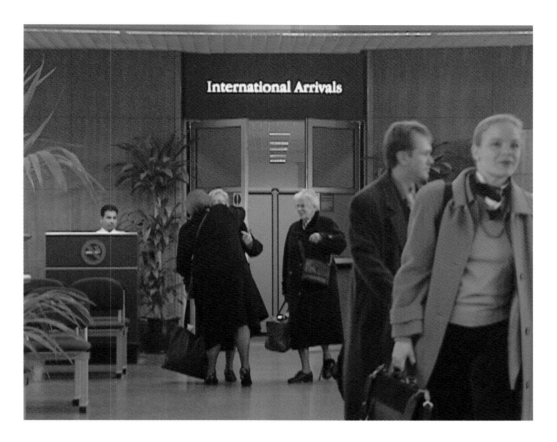

Desk, 1989

Object Lesson, 1990/5

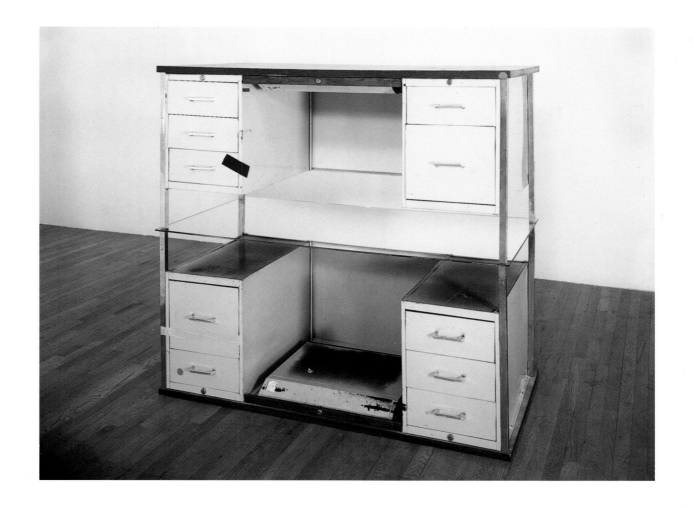

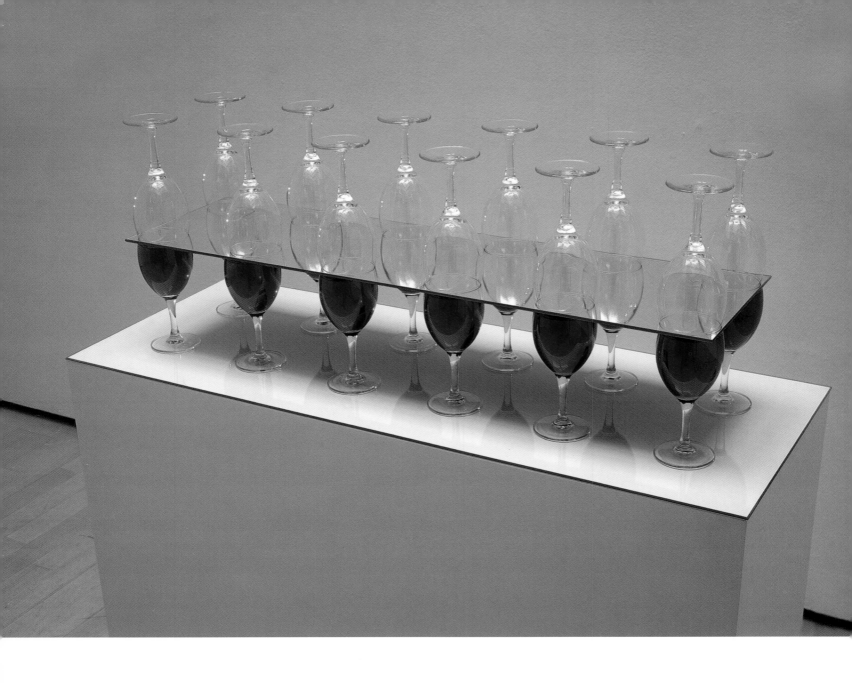

Miracle, 1997

Miracle, Credo I and **II, The Word in the Desert**, installation shot
OVERLEAF: **The Word in the Desert I, II, III** and **IV**, 2000

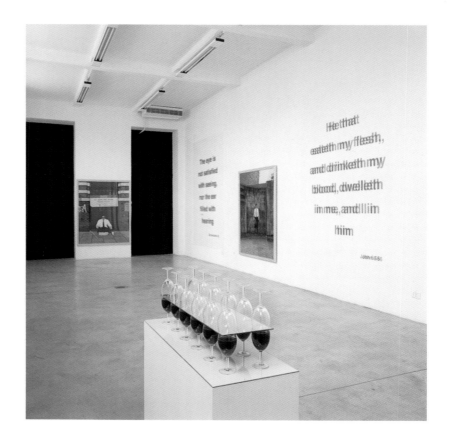

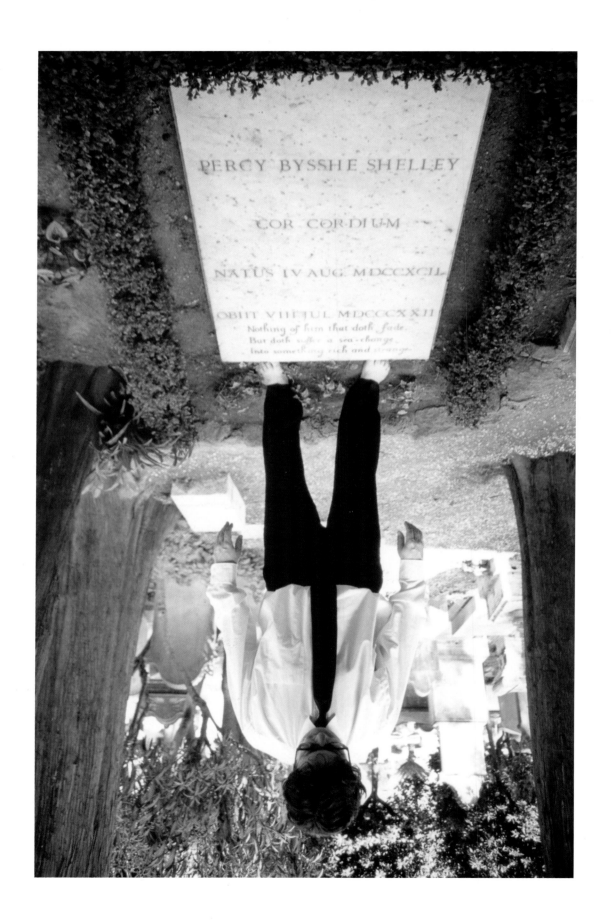

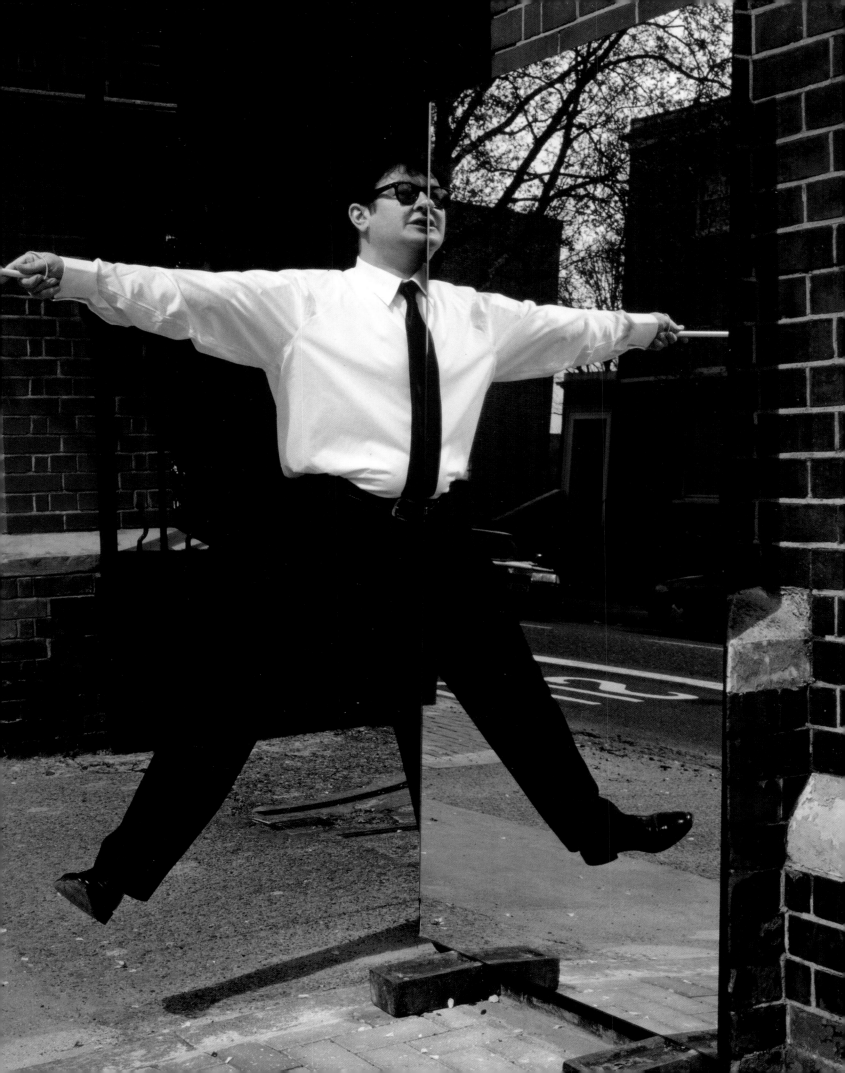

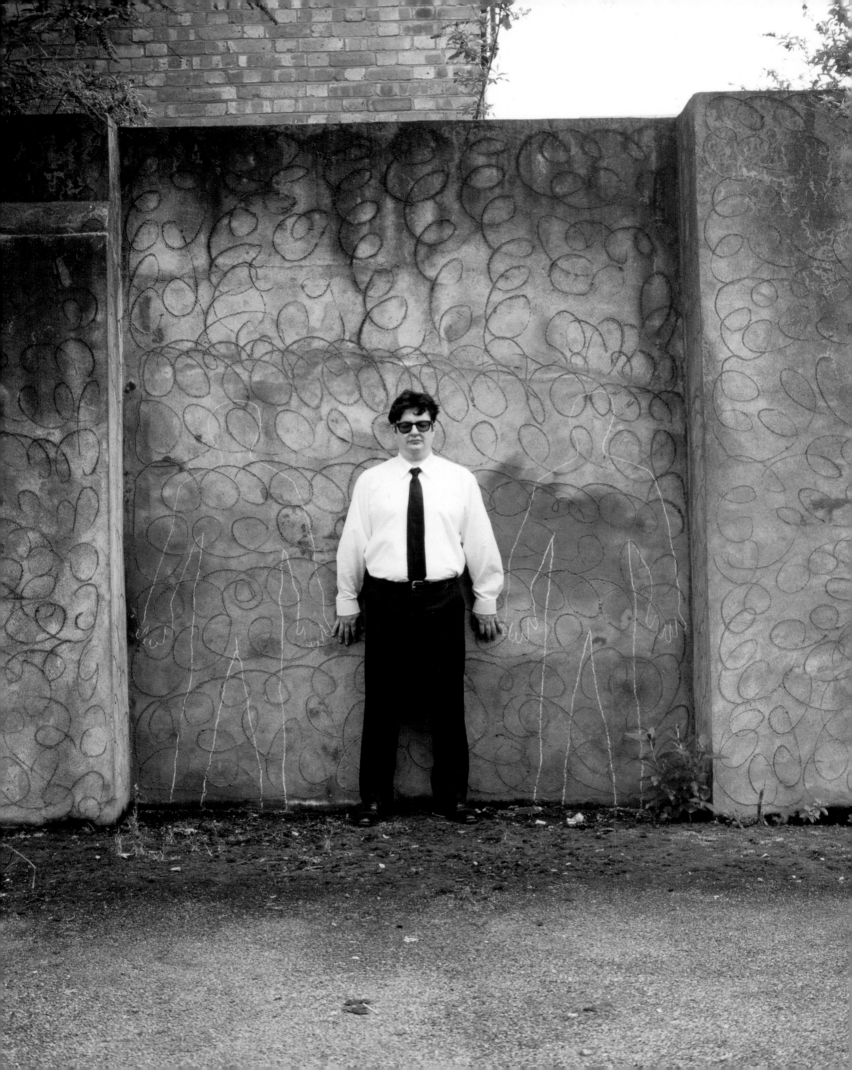

Oh no he isn't, oh yes he is, 1993
Pantomime costume, fibre glass resin
177.3 x 132 x 58.5 cm
P 59

Regard A Mere Mad Rager, 1993
Video monitor, mirror
Dimensions variable
P 100, 101

Self Portrait as Emily Davison, 1993
Colour photograph on aluminium
89 x 137 cm
Edition of 3 + 1 Artist Proof
P 64

A Real Work of Art, 26 September 1994,
1994
Colour photograph
20 x 25.5 cm
Edition of 30
P 65

Q1, 1994
Acrylic on canvas
218.5 x 218.5 cm
Private Collection, Zürich
P 7

Q2, 1994
Acrylic on canvas
218.5 x 218.5 cm
Private Collection, London
P 8

Q3, 1994
Acrylic on canvas
218.5 x 218.5 cm
Private Collection, London
P 82

Q4, 1994
Acrylic on canvas
218.5 x 218.5 cm
P 83

Q5, 1994
Acrylic on canvas
218.5 x 218.5 cm
NORD/ LB Norddeutsche Landesbank
P 102

**Mark Wallinger, 31 Hayes Court,
Camberwell New Road, Camberwell,
London, England, Great Britain, Europe,
The World, The Solar System, The Galaxy,
The Universe**, 1994
Laminated colour photograph on MDF
327.6 x 487.7 cm
P 104, 105

Royal Ascot, 1994
Video installation for four monitors
Edition of 3 + 1 Artist Proof
The British Council
P 94, 95

Untitled, 1994
Installation with grand piano and recorded
sound in Derek Jarman's studio,
53 South Edwardes Square, London
P 96
Not on display

**Half-Brother
(Exit to Nowhere – Machiavellian)**, 1994-5
Oil on canvas
230 x 150 cm
Tate Collection, London
Not on display
P 63

**Half Brother
(Jupiter Island – Precocious)**, 1994-5
Oil on canvas
230 x 300 cm
Collection Vanhaerents, Torhout,
Not on display
P 62

My Little Eye, 1995
Oil on canvas, glass-eye, frame
74.5 x 74.5 cm
Jederman Collection, N A
P 54
Not on display

Q6, 1995
Acrylic on canvas
218.5 x 218.5 cm
Konsumgenossenschaft Berlin und
Umgegend eG, Germany
P 103

Q7, 1995
Acrylic on canvas
218.5 x 218.5 cm
P 121

Q8, 1995
Acrylic on canvas
218.5 x 218.5 cm
P 122

Autopsy, 1996
Wood, books
115 x 122 x 61 cm
P90

Oxymoron, 1996
Flag
Dimensions variable
P 92, 93

Angel, 1997
Projected video installation
7'30" (loop)
Edition of 10 + 1 Artist Proof
P 48, 49

Hymn, 1997
Projected video installation
4'52" (loop)
Edition of 10 +1 Artist Proof
P 85

Mark Wallinger is Innocent, 1997
Ink on paper
Dimensions variable
FRAC, Nord/ Pas-de-Calais, Dunkirk
P 14
Not on display

Miracle, 1997
24 glasses, wine, mirror, plinth
78 x 85.6 x 36.3 cm
P 112,

Seeing is Believing, 1997
Screen printed light boxes
Three parts, each 127 x 127 x 20 cm
P 98, 99

**The Importance of Being Earnest in
Esperanto**, 1997
Found video, 100 chairs
Emmanuel Hoffman Foundation,
Depositum Museum für Geganwartskunst,
Basel
P 56, 57
Not on display

Upside Down and Back to Front, the Spirit Meets the Optic in Illusion, 1997
Glass, water, plastic, paper, mirror on plinth
148 x 80 x 80 cm
P 79, 80, 81

On an Operating Table, 1998
Projected video installation
Dimensions variable
13 minutes (loop)
Edition of 3 + 1 Artist Proof
Anthony Reynolds Gallery
P 10

The Four Corners of the Earth, 1998
Slide projection on four circular canvases
Each 230 cm diameter
Arts Council Collection, London
P 75, 76, 77

When Railway Lines Meet at Infinity, 1998
Projected video installation (continuous loop)
Edition of 3 + 1 Artist Proof
P 52, 53
Not on display

Ecce Homo, 1999
White marbelised resin, gold leaf, barbed wire
Life size
Commissioned work for Trafalgar Square, London
Edition of 3 + 1 Artist Proof
P 39, 40, 41, 42
Not on display

Prometheus, 1999
Projected video installation
Continuous video loop
Edition of 10 + 1 Artist Proof
P 67, 68, 69, 70, 71, 72

Credo I, 2000
Ink printed on paper
Dimensions variable
P 13

Credo II, 2000
Ink printed on paper
Dimensions variable
P 37

Fly, 2000
Video to be shown on a monitor (loop)
Edition of 10 + 1 Artist Proof
P 74

Threshold to the Kingdom, 2000
Projected video installation
11'10"
Edition of 10 + 1 Artist Proof
P 108, 109

The Word in the Desert I, 2000
Framed colour photograph
190 x 130 cm
Edition of 5 + 1 Artist Proof
P 114

The Word in the Desert II, 2000
Framed colour photograph
190 x 154 cm
Edition of 5 + 1 Artist Proof
P 115

The Word in the Desert III, 2000
Framed colour photograph
190 x 154 cm
Edition of 5 + 1 Artist Proof
P 116

The Word in the Desert IV, 2000
Framed colour photograph
190 x 154 cm
Edition of 5 + 1 Artist Proof
P 117

Cave, 2000
Four screen projected video installation with sound
Dimensions variable
14 minutes
Cave is a FACT commission in collaboration with Tate Liverpool made possible with financial support from the Arts Council of England's Touring Programme and North West Arts Board.
P 32, 33, back cover

Q7, 1995

Q8, 1995

MARK WALLINGER

Born in 1959
Lives and works in London

1977-78
Loughton College

1978-81
Chelsea School of Art, London

1983-85
Goldsmith's College, London

1995
Turner Prize Shortlist, Tate Gallery, London

1998
Henry Moore Fellowship, British School at Rome

2000
Research Fellow, University of Central England, Birmingham
DAAD, Berlin

2001
Venice Biennale, British Pavilion

SOLO EXHIBITIONS

1983
The Minories, Colchester

1986
Hearts of Oak, Anthony Reynolds Gallery, London

1988
Burgess Park, Nottingham Castle Museum, Nottingham
Passport Control, Riverside Studios, London
Anthony Reynolds Gallery, London *

1990
School, Sophia Ungers, Cologne
Stranger², Anthony Reynolds Gallery, London

1991
Capital, Grey Art Gallery, New York
Daniel Newburg Gallery, New York
Capital, Institute of Contemporary Art, London
touring to Manchester City Art Gallery *

1992
Fountain, Anthony Reynolds Gallery, London

1993
Daniel Newburg Gallery, New York

1994
The Full English, Anthony Reynolds Gallery, London

1995
Ikon Gallery, Birmingham *
Serpentine Gallery, London

1997
Deweer Art Gallery, Otegem
God, Anthony Reynolds Gallery, London
The Importance of Being Earnest in Esperanto, Jiri Svetzka Gallery, Prague

Dead Man's Handle, Canary Wharf Window Gallery, London
Dolly Fiterman Fine Arts, Minneapolis *

1998
The Four Corners of the Earth, Delfina, London

1999
Mark Wallinger is Innocent, Palais des Beaux Arts, Bruxelles *
Prometheus, Portikus, Frankfurt *
Ecce Homo, The Fourth Plinth, Trafalgar Square, London
Lost Horizon, Museum für Gegenwartskunst, Basel *

2000
Threshold to the Kingdom, The British School, Rome
Galeria Laura Pecci, Milan
Dream Machine, Musee de Beaux Arts, Nantes
Ecce Homo, Vienna Secession, Vienna *
Credo, Tate Liverpool, Liverpool *

GROUP EXHIBITIONS

1981
New Contemporaries, ICA, London

1982
Space Invaders, St Mary's Art Centre, Colchester

1984
Whitechapel Open, Whitechapel Art Gallery, London

1985
Prelude, Kettle's Yard, Cambridge
New Art 2, Anthony Reynolds Gallery, London

1986
Canvass: New British Painting, John Hansard Gallery,
Southampton, and The Exhibition Gallery, Milton Keynes
Unheard Music, City Museum and Art Gallery, Stoke-on-Trent *
New Art, Anthony Reynolds Gallery, London
Neo Neo-Classicism, Edith C Blum Art Institute, Bard College,
Annandale-on-Hudson, New York *

1987
Serpentine Gallery, London
Appropriate Pictures, Anthony Reynolds Gallery, London
State of the Nation, Herbert Art Gallery, Coventry *
Palaces of Culture: The Great Museum Exhibition, City Museum
and Art Gallery, Stoke-on-Trent *

1988
**Cries and Whispers, paintings of the Eighties in the British Council
Collection**, touring Australia *
Sculptures, Koury Wingate, New York
Something Solid, Cornerhouse, Manchester *
Image and Object: Aspects of British Art in the 1980s, Stoke-on-Trent *
The New British Painting, The Contemporary Arts Center,
Cincinnati, and touring *

1989
Territories, Chisenhale Gallery, London
Einleuchten: Will, Vorstel und Simul in HH,
Deichtorhallen, Hamburg *

1989
Excommunication: Some Notions on Marginality, Grey Art Gallery, New York
Anthony Reynolds Gallery, London

1990
The Köln Show, Cologne *
Australian Sculpture Triennial, National Gallery of Victoria *

1991
Kunstlandschaft Europa, Kunstverein Karlsruhe *
Confrontaciones, Palacio de Velasquez, Madrid *

1992
Whitechapel Open, Clove Building, London *
Let Me Look, San Miniato *

1993
Young British Artists II, Saatchi Collection, London *
Spit in the Ocean, Anthony Reynolds Gallery, London
You've Tried the Rest, Now Try the Best, City Racing, London
Mandy loves Declan 100%, Mark Boote Gallery, New York *
MA Galerie, Paris
Young British Artists from the Saatchi Collection, Koln *

1994
Jet Lag, Galerie Martina Detterer, Frankfurt
Every Now and Then, Rear Window / Richard Salmon, London
Not A Self Portrait, Karsten Schubert Gallery, London
Five British Artists, Galleri Andrehn Schiptjenko, Stockholm *
Here and Now, Serpentine Gallery, London
Untitled Streamer Eddy Monkey Full Stop Etcetera, Anthony Reynolds Gallery, London
Art Boutique, Laure Genillard Gallery, London
Seeing the Unseen, Thirty Shepherdess Walk, London *
Idea Europa, Palazzo Publico, Sienna *
A Painting Show, Deweer Art Gallery, Otegem *
Art Unlimited, Arts Council Touring Show *

1995
The Art Casino, Barbican Art Gallery, London
John Moores Exhibition 19, Walker Art Gallery, Liverpool
The British Art Show, Manchester and tour *
The Turner Prize, Tate Gallery, London *

1996
Rhona Hoffman Gallery, Chicago
Anthony Reynolds Gallery, London
Offside! Manchester City Art Gallery, Manchester
10th Biennale of Sydney, Sydney *

1997
Animal, CCA, Glasgow
Pledge Allegiance to a Flag?, London Printworks Trust, London *
Pictura Britannica, Museum of Contemporary Art, Sydney, Art Gallery of South Australia, Adelaide, Te Papa, New Zealand *
Sensation, Royal Academy of Arts, London; Hamburger Banhof, Berlin *
5th Istanbul Biennale, Istanbul *
2nd Johannesburg Biennale, Johannesburg
P..er.sonal...Absurdities, Galerie Gebauer, Berlin

1998
Wounds, Moderna Museet, Stockholm *
Dissin' the Real. Lombard Fried Gallery, New York, Galerie Ursula Krinzinger, Vienna
Drawing Itself, The London Institute, London *
Heatwave, The Waiting Room, Wolverhampton
Made In London, Museu de Electricidade, Lisbon *
Anthony Reynolds Gallery, London
U.K. Maximum Diversity, Benger Areal, Bregenz *
Heatwave, Electricity Showroom, London
Book, Djanogly Art Gallery, Nottingham *
1st Biennale de Montreal, Montreal *
Il passato nel Presente, The Tannery, London
Shunted, Sheffield
Contemporary British Artists, Denver Art Museum, Denver

1999
L'Art et l'Ecrit, Espace Sculfort, Maubeuge *
Fourth Wall, National Theatre, London
Il passato nel Presente, Maze Art Gallery, Turin
Il luogo degli angeli, San Michele and Museo Laboratorio, San Angelo touring to Lucca *
Changement d'air, Musée d'art moderne Lille Métropole, Villeneuve d'Ascq
Officina Europa, Villa delle Rose, Galleria d'Arte Moderna, Bologna and tour *
The Sultan's Pool, Jerusalem

2000
Vision Machine, Musee des Beaux-Arts de Nantes, Nantes
On the Frac Track (Text as Image), Sevenoaks Library Gallery, Kent
Maidstone Museum & Bentlif Art Gallery, Kent
Rochester Art Gallery, Kent
Maidstone Library Gallery, Kent
The Royal Museum & Art Gallery, Canterbury, Kent
Sassoon Gallery, Kent
Seeing Salvation, National Gallery London *

* publication

BIBLIOGRAPHY

1985
Waldemar Januszczak, 'New Art', *The Guardian*, 27 August

1986
Marjorie Allthorpe-Guyton, 'New Art I and II at Anthony Reynolds Gallery', *Artscribe*, December-January, no 55
R. Costa, 'London', *Juliet*, December-January, no 23
Sarah Kent, *Time Out*, 23-29 January
Mark Currah, *City Limits*, 31 January-6 February
John Russell Taylor, 'Mark Wallinger: Hearts of Oak', *The Times*, 4 February
Waldemar Januszczak, *The Guardian*, 7 February
SC, 'A Mixed Message', *London Week*, 7-13 February
Clare Henry, *Arts Review*, 14 February, vol. 38, no. 3
Marjorie Allthorpe-Guyton, *Artscribe*, April-May, no 57
Monica Bohm-Duchen, *Flash Art*, April, no 127
Tessa Sidey, 'Unheard Music', *Arts Review*, May
Margaret Garlake, 'Canvas II', *Art Monthly*, July-August

John Roberts, 'Mark Wallinger's History Paintings', *Artscribe*,
January-February
Waldemar Januszczak, 'Stuart Brisley at the Serpentine',*The Guardian*,
21 January
Monica Petzal, 'Stuart Brisley, Glenys Johnson, Mark Wallinger,
Ken Currie', *Time Out*, 28 January-4 February
'Ken Currie, Glenys Johnson, Mark Wallinger', *The Observer*, 1 February
Nigel Reynolds, 'Art or Just brick-a-brac?', *London Evening Standard*,
14 September
David Wickham, 'Building an art of stone', *News on Sunday*,
20 September
Andrew Graham-Dixon, 'A Museum of Mirrors', *The Independent*,
25 September
ES Magazine, *Evening Standard*, Friday 6 November
John Glaves-Smith, 'Palaces of Culture', *Art Monthly*,
December-January, no 112

1987
Peter Fleissig, 'Artists for Architecture', *Building Design*, 18 March
Jutta Koether, *Artscribe*, May, no 69
David Lovely, 'Something Solid', *Arts Review*, May
Mark Edmund, 'Something Solid', *Pulp Magazine*, 10 May
Jude Schwendenwien, 'Sculpture, Koury Wingate', *Artnews*,
Summer, no.87

1988
Mark Currah, *City Limits*, 29 September-6 October
Robert MacDonald, *Time Out*, 12-19 October
Brian Hatton, 'Mark Wallinger', *Flash Art*, November-December, no.143
P H Meyer, 'Mark Wallinger', *Juliet Art Magazine*, December-January,
no.39

1989
Michael Archer, 'Mark Wallinger', *Artforum*, January

1990
Sarah Kent, 'Mark Wallinger', *Time Out*, 2-9 January

1991
Levin, Choices, *Village Voice*, 26 February
Dorothy Spears, 'Mark Wallinger', *Arts Magazine*, May
Andrew Graham-Dixon, *The Independent*, 14 May
Sarah Kent, Politics in Paint, *Time Out*, 15-22 May
Sacha Craddock, 'Truth or Dare?', *The Guardian*, 28 May

1992
Richard Cork, 'A picture of wealth', *New Statesman Society*, 31 May
Jutta Koether, 'Mark Wallinger', *Artscribe*, Summer, no.87
Janet Koplos, *Art in America*, July
Fernando Arias, 'La renovacion de la pintura anglosajona',
Hoja de Lunes, *Valencia*, 15 July
Alessandrs Gulotta, 'Let Me Look', *Next*, October, no.27
Alberto Mugnaini, 'Luoghi Storici del Paese', *Tema Celeste*, October
Saretto Cincinelli, 'Let Me Look', *Flash Art*, October-November
Alessndro Tosi, 'Quel Magico Accordo', *La Nazione*, 5 November
Conor Joyce, 'Mark Wallinger', *Art Monthy*, November
Andrew Wilson, 'Mark Wallinger', *Forum International*,
November-December
Andrew Renton, 'Mark Wallinger', *Flash Art*, November-December
Mario Manganiello, 'Artisti Inglesi Contemporanei A San Miniato',
Images; Art Life, November-December, no.23
Juliet Art Magazine, Anno XII, December, no.60

Stella Santacaterina, 'Mark Wallinger', *Tema Celeste*, Winter

1993
Adrian Searle, 'Fools and Horses', *Frieze*, January-February, no.8
William Feaver, 'The Second Coming', *Vogue*, February
James Hall, 'Diary', *The World of Interiors*', February
Sarah Kent, 'Less is Gore', *Time Out*, 2-9 February
Richard Cork, *The Times*
David McKie, 'What You Read into It', *The Guardian*, 6 February
Tim Hilton, 'Familiar Signs of a misspent youth', *The Sunday Review*,
The Independent on Sunday, 7 February
Waldemar Januszczak, 'Blood and Thunder', *The Guardian*, 8 February
Sacha Cradock, 'Young British Artists', *Untitled*, Spring
Sarah Kent, 'Blood Group', *Time Out*, 10-17 February
William Feaver, 'Phew! What a freezer!', *The Observer*, 14 February
Andrew Graham-Dixon, 'Radical chic and the schlock of the New',
The Independent, 16 February
William Packer, 'Young British Artists II at the Saatchi Gallery',
Financial Times, 16 February
Stephen Pile, 'Don't put the Nail in the Coffin Yet',
The Daily Telegraph, 18 February
Julian Stallabrass, 'Young British Artists', *Art Monthly*, March
Peter Fleissig, 'Leche-Vitrine', *Parkett*, no 35
Simon Garfield, 'I like it, I'll take the lot', *The Independent*, 20 March
Craig Brown, 'Time for an Artful Dodge', *The Evening Standard*,
22 March
Andrew Renton, 'Young British Artists II', *Flash Art*, Summer
Werner Kruger, Junge britische Kunstler, *Weltkunst*, 15 October
Kolner Stadt-Anzeiger, 5 November

1994
Bunte, 11 November
Bruno F Schneider, 'Mit drunem Licht zaubern', *Kolnische Rundschau*,
15 November
Angela Choon, 'Openings', *Art & Antiques*, December
Richard Dorment, 'Throw that work of art another bale of hay',
The Daily Telegraph, 17 March
Paul Bonaventura, 'Turf Accounting', *Art Monthly*, April, no.175
Adrian Dannatt, 'Young British Art Now', *The Sunday Times Magazine*,
17 April
James Hall, 'Horsing Around', *The Guardian*, 25 April
Mark Currah, 'Mark Wallinger', *Time Out*, 4-11 May
David Lee, 'Update', *Art Review*, May
Roger Bevan, 'The Horse as an Art Form', *The Art Newspaper*,
May, no.38
Dalya Alberge, 'Artist's latest work is a racing certainty for controversy',
The Independent, 14 May
James Hall, 'The Guide', *The Guardian*, 11 June
Paul Bonaventura, 'A Equal Match?', *Modern Painters*, Summer
Jeffrey Kastner, 'Mark Wallinger', *Flash Art*, June
William Harvey, 'Curators' Egg', *Untitled*, Summer
William Harvey, 'Rear Window', *Untitled*, Summer
Mark Currah, 'Every Now and Then', *Frieze*, June-July-August
Matthew Collings, 'New London', *The Daily Express*, 5 September

1995
Geraldine Norman, *The Independent on Sunday Reviews*, 1 January
Giles Coren, *The Times*
Adrian Searle, 'Self Portrait as a pantomime horse', *The Guardian*,
7 March

1995
'Mark Wallinger', *Blueprint*, March
William Feaver, 'Horse for courses', *The Observer Review*, 19 March
William Packer, 'An Artist lays his Bets', *Financial Times*, 13-14 May
Martin Vincent, 'Painters and Punters', *New Statesman and Society*,
19 May
Londoner's Diary, *Evening Standard*, 23 May
Richard Cork, 'Our Nation at Horseplay', *The Times*, 30 May
'London Review', *Art Review*, June
Sarah Kent, 'Race Relation', *Time Out*, 31 May-7 June
Sarah Curtis, 'Blood Lines', *World Art*, no.2
Andrew Graham-Dixon, 'The British Art Buzz', *Vogue*, June
Waldemar Januszczak, 'His Sporting Life', *The Sunday Times*, 4 June
Martin Gayford, 'Favourite with a Handicap', *The Daily Telegraph*,
7 June
Robert Lloyd Parry, 'Ideas of Englishness', *This is London*, 9 June
Mark Sanders, 'Eye opener', *The London Magazine*, May
Philip Vann, 'Backing the Right Horse', *RA Magazine*, Spring, no.46
Louisa Buck, 'British Art: don't knock it', *Independent Weekend*,
24 June
Mark Wallinger, 'A Brush with genius: 1', *The Guardian*, 3 July
Mike Ellison, 'No Butts as Hirst is Tipped for Top Art Prize',
The Guardian, 13 July
Dalya Alberge, 'Colourful Rebels Vie for Turner Prize', *The Times*, 13 July
David Lister, 'Turner Artists inquires within', *Independent*, 13 July
Dan Conaghan, 'Dead Mutton Dressed up as Sheep', *The Guardian*,
13 July
David Lister, 'It may win Prizes, but is it Art or Orifice?', *Independent*,
14 July
Simon Wilson and Brian Sewell, 'Mark Wallinger's A Real Work of Art',
Independent, 14 July
Antony Thorncroft, 'Sheep leads the horses in Turner stakes',
Financial Times, 22 July
Mark Sladen, 'Mark Wallinger', *Frieze*, September-October, no.24
Mark Currah, 'Mark Wallinger in London', *Untitled*
Rupert Christiansen, 'Dark Horse of the Art World', *The Daily Telegraph
Magazine*, 21 October
Adrian Searle, 'The Thirst for Hirst', *The Independent*, 1 November
Dan Conaghan, 'Tate Shows Turner Prize Cream but not the Cow',
The Daily Telegraph, 1 November
James Hall, 'Turner Exhibition comes alive and dangerous',
The *Guardian*, 1 November.
Edward Gorman, 'Leaky Works of Art put out to grass', *The Times*,
1. November.
Richard Cork, 'Hirst commands two fronts', *The Times*, 7 November
Richard Dorment, 'Beauty amid the Beasts', *The Daily Telegraph*,
8 November
Matthew Collings, 'The Art of Prize Fighting', *The Guardian*,
28 November
Tina Jackson, 'Mark Wallinger: Horse Crazy', *The Big Issue*,
12-18 February

1996
Andrew Sim, 'A Real Work of Art', *The Sporting Life*, 29 January
Ian Gale, '20th Century Sporting Art', *Country Life*, 7 March
The List, 8-21 March
'He's behind you!', *The Sun*, 23 February
Scottish Daily Mail, 23 February
Annie Griffin, 'Eyes on the ball', *The Guardian*, 10 June
Bridget Virden, 'Stud-U-Like,' (interview), *Homepage!*

Jason Coburn, 'photo-finish', a conversation between Jason Coburn
and Mark Wallinger. *Hello, Artists in Conversation*, published by
The Royal College of Art, London

1997
Ada Adekola, Yinka Shonibare, Mark Wallinger, *Time Out*,
22-29 January
David Burrows , Ada Adekola, Yinka Shonibare, Mark Wallinger,
Art Monthly, February
Martin Coomer, 'Mark Wallinger', *Time Out*, 2-9 April.
John Tozer, 'Mark Wallinger, God', *Art Monthly*, May, no. 206
Lottie Hoare, 'Mark Wallinger', *Untitled*, Spring
Isobel Johnstone, 'Who's buying who?', *The Guardian*, 3 June
Jean-Marc Colard, 'Union Mark', *Les Inrockuptibles*, 23-29 April,
no. 101
The Guardian, 19 September
'The Art Pack' , *Elle*, October
'Mark Wallinger at Jiri Svestka', *Flash Art*, November-December,
no. 197

1998
Carol Kino, 'Dissin' the Real', *Time Out New York*, 10 March
'Von Endorphinen, Salzgurken und Stromstˆflen', *Der Standart*, 5 June
'Minimalsport mit Erwin Wurm und vieles mehr', *Kurier*, 6 June
Mark Wallinger, 'The Pygmalion Paradox', *Art Monthly*, July-August
Duncan McLaren, 'The Four Corners', *The Independent on Sunday*,
8 November
Ian Geraghty, 'Mark Wallinger', *Untitled*, Autumn
John Harlow, 'Christ to get place in Trafalgar Square', *The Sunday
Times*, 20 September
Helen Sumpter, 'Mark Wallinger: The Four Corners of the Earth',
Evening Standard, 1 October
The Art Newspaper, Vol.X, October, no 85
Contemporary Visual Arts, Issue 20
ArtClub, Autumn
Exhibit:A , 'Mark Wallinger: The Four Corners of the Earth', September-
October
Mark Currah, *Time Out*, 28 October- 4 November
Rachel Campbell-Johnston, *The Times*, 6 October
The Guardian Space, 'Mark Wallinger: The Four Corners of the Earth', 9
October
The Guide 'Mark Wallinger', 3-9 October
Helen Sumpter, 'Mark Wallinger: The Four Corners of the Earth',
The Big Issue, 12-18 October, no.305
Kevin Davey, 'Mark Wallinger', English Imaginaries ,
Lawrence & Wishart
Matthew Collings, 'Battle of Trafalgar Square', *The Observer*, 6
December
Dan Glaister, 'Modern art to the rescue of Trafalgar Square's empty
plinth', *The Guardian*, 8 December
John Tozer, 'From today painting is dead', *Contemporary Visual Arts*,
no. 21
'Who's Afraid of Red White & Blue? Attitudes to popular & mass culture,
celebrity, alternative & critical practice & identity politics in recent British
art', *Article Press*, Birmingham

1999
Neal Brown, *Frieze*, January-February. no. 44
Eleanor Heartney, 'Report from Montreal', *Art in America*, February
Stella Santacatterina, 'Mark Wallinger', *Flash Art*, March-April

Fiachra Gibbons, 'Behold Jesus, just another ordinary bloke',
The Guardian, 22 July

Adrian Searle, 'The Day I met the son of God', *The Guardian*, 22 July

'The plinth and the people', *The Guardian*, 22 July

Alex Hendry, 'Jesus starts a new battle of Trafalgar', *The Express*,
22 July

Will Bennett, 'Christ fills a gap in heart of London', *The Daily Telegraph*,
22 July

David Lister, 'Humble Christ beats war-like Thatcher', *The Independent*,
22 July

Dalya Alberge, 'Christ stirs passion in Trafalgar Square', *The Times*,
22 July

'Centre of attention, public statues', *The Times*, 22 July

Sir Roy Strong, 'Is this a fitting site for a statue of Jesus Christ?',
Daily Mail, 22 July

Mark Wallinger, *My Week*, *The Independent*, 24 July

Phil Miller, 'New Statue of Jesus dwarfed by giants of Empire',
The Scotsman

Warren Hoge, 'Plinth Seeks Occupant. Nelson will be Neighbour',
New York Times, 19 August

Warren Hoge, 'A Finishing Touch for Trafalgar Square',
International Herald Tribune, 21-22 August (ill.)

Richard Dorment, 'Small figure makes a big impact', *The Daily
Telegraph*, 25 August

Lucy Lethbridge, 'The Plinth's Progress', *ArtNews*, October

Warren Hoge, 'A finishing touch', *Vocable*, 21 October-3 November

James Hall, 'Short of statue', *Artforum*, November

Jonathan Jones, 'Mark Wallinger's Christ', *The Guardian*, 27 December

Kate Watson-Smyth and Fran Abrams, 'Captain Cook and Batman
fight for a place at the heart of nation', *The Independent*, 27 December

Adrian Searle, 'Brush Hour', *The Guardian*, 28 December

2000

Lynn Barber, 'For Christ's sake', *The Observer*, 9 January

Ann Treneman, 'Art, farce, politics and pigeons', *The Times 3*,
11 February

Colin Gleadall, 'Edge of meaning and nonsense', *The Daily Telegraph*,
22 July

Louisa Buck, 'Moving Targets 2', *Tate Gallery Publishing Limited*

Simon Grant, 'Soul Searching', *Tate: The Art Magazine*,
Summer 2000, issue no. 22

Daniel Perra, 'Tema Celeste Contemporary Art', July-September 2000, no. 8